D1484224

ANATOMY
FOR ARTISTS

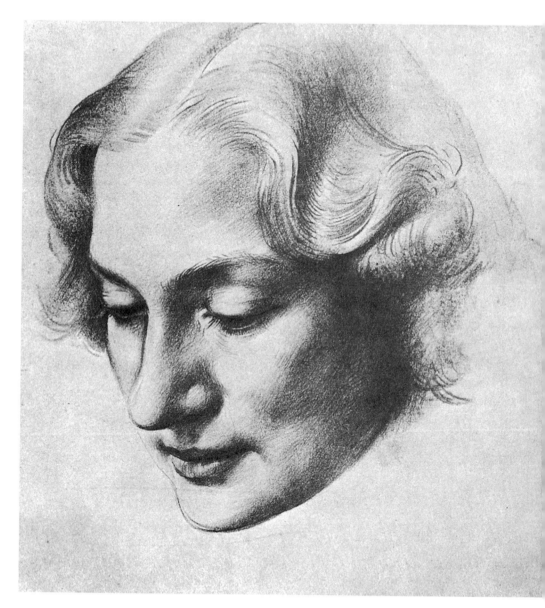

HEAD OF A YOUNG WOMAN

ANATOMY FOR ARTISTS

Diana Stanley

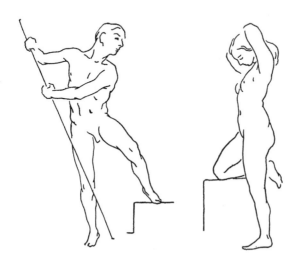

DOVER PUBLICATIONS, INC.
Mineola, New York

Bibliographical Note

This Dover edition, first published in 2003, is an unabridged republication of the work originally published by Pitman Publishing Corporation, New York, in 1951.

Library of Congress Cataloging-in-Publication Data

Stanley, Diana L.
 Anatomy for artists / Diana Stanley.
 p. cm.
 Originally published: New York : Pitman Pub. Corp., 1951.
 Includes index.
 ISBN 0-486-42981-4 (pbk.)
 1. Anatomy, Artistic. I. Title.

NC760.S76 2003
743.4'9—dc21

 2003048965

Manufactured in the United States of America
Dover Publications, Inc., 31 East 2nd Street, Mineola, N.Y. 11501

CONTENTS

PREFACE

Although the average student is distracted and unable to make much headway without some knowledge of anatomy, he does not want to be cumbered with too many facts, nor does he to wade through a lot of reading. I have attempted to keep the artist's requirements in mind throughout this book and, wherever possible, to relate the anatomical structures of the human body to its surface appearances. I should have liked to have included many more drawings, but I hope that the student will be able to continue where my efforts cease, and study for himself or herself on the basis I have presented in this book.

I am indebted to many people, and I hope this book is worthy of their help and advice. Particularly I would like to thank Lord Webb-Johnson for allowing me to study dissections in the Royal College of Surgeons; and Professor F. Goldby for letting me make use of the Anatomical Department at St Mary's Hospital. This book, however, would never have been completed but for the constant help I have been given by Professor C. A. Pannett, and I owe a real debt of gratitude to him.

INTRODUCTION

The artist's intention must be to communicate his vision to the minds of others. It has been said that man is an artist as soon as he imagines and long before he reasons. There is probably an artist latent in everyone's nature, though he or she may be incapable of translating his or her vision into terms which are understandable to other people. The would-be artist must learn all the possibilities of the medium at his disposal. The draughtsman or painter deals with the visual world; it is in nature that he must look for the symbols which will convey his meaning and imagination to others. He must learn the language of drawing, whether with pencil, pen or paint.

Drawing requires the co-ordination of the eye and the mind. Visual objects are seen by the eye, but they are interpreted by the mind. While the eye sees only the surface texture of a thing, the mind grasps its complete entity and understands its qualities. Nature to the eye is two-dimensional; to the mind it is three-dimensional. The eye sees only what is apparent from one point of view; the mind comprehends through previous impressions of sight other aspects and qualities which are concealed from the eye. It is these mental aspects of nature and of the human figure in particular which the student must convey if his work is to mean anything to other minds.

Sight gives facts to the mind. By correlating these facts the mind perceives certain relationships; it selects and comments, it emphasizes certain facts which seem important whilst rejecting others which are not relevant. Trained by the mind's requirements the eye will learn to inform more accurately and grow quick to observe essentials, noting the less important details only when the mind requires their inclusion into the drawing. The artist's mind and imagination sort out and isolate certain qualities from nature, rejecting other aspects which seem to him of lesser worth, thus creating a world in the image of his own mind.

The study of anatomy in relation to the art student is rather similar to the many studies which school education teaches us, but which we afterwards reject. Anatomy, like Greek or Latin or mathematics, trains the mind to grasp ideas and to perceive relationships; it makes us think and brings us to an understanding of nature and of life from which we must eventually make our own departure, expressing what we as individuals, living in our own day, think and feel. The importance of anatomical study lies not so much in the facts it presents us with, but in our learning to analyse, correlate and understand.

INTRODUCTION

Drawings of the human figure must be made in many ways, in quick action studies, and in the study of isolated relationships. It is important that the student should learn to carry a figure drawing right through all the details of its forms to the extremities of the limbs. He should resist as far as possible the temptation he is so often bound to feel to abandon the first attempt before he has got anywhere at all, and start again. Let him learn to make the corrections on the drawing he wants to scrap; let him put away his rubber and state positively what it is he thinks on the drawing he imagines is beyond redemption. The only satisfactory way to make amends is to superimpose good drawing on bad. If the student does not persevere with every separate study, carrying it through to its ultimate end, each new beginning will arrive only at the same unfinished stage, and he will never be able to make a good drawing from fear of making a bad one. Let the student make a study of the figure one day from the anatomical point of view, and the next day let him make a drawing of his own particular vision or conception of the same pose, ignoring the anatomical aspect. He will probably find that he has assimilated ideas from his anatomical study which now become, as it were, the language by which he can express with more convincing realism the forms before him. He will eventually learn in this way to convey by simple outline the whole content of the forms within. He will no longer simply trace the outline; this same outline will become in his drawing the boundary of enclosed forms. But he cannot do this unless he first makes studies with all the modelling from all aspects and with all detail. Failing this the student must create formulas; but formulas deprive his work of that sense of reality which direct study from nature always gives. Sooner or later the repeated use of formulas will dull the mind and stifle the creative ability.

The student's problem is to learn how he can translate his mental perceptions into visual terms. How can he express the hidden by means of the seen using light, shade and outline seen on the model in such a way as to convey forms and qualities which are not apparent to the eye?

The student must first learn to think of the outline of the forms as horizons. As he shifts from one point of view to another, looking at the model from different angles, so the outlines also alter and move round the figure to represent the boundaries of the forms as they disappear from view. If he views the model in his imagination at right angles to the position from which he has chosen to draw, he will understand that the figure is composed, not merely of shaded areas limited abruptly in width and height by edges, but of forms which are contained by curved surfaces. The outline, in fact, is not confined to one plane but is made up of numerous limiting contours, some parts of which advance while others recede. Observing this, the student should treat the outlines everywhere as elements of the boundaries of formations which disappear behind one another and reassert themselves above or below or round the other side of the figure.

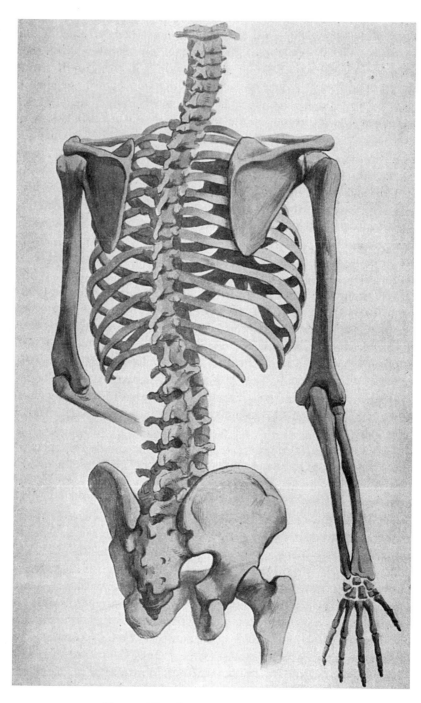

FIG. 1. THE SKELETON FROM THE BACK

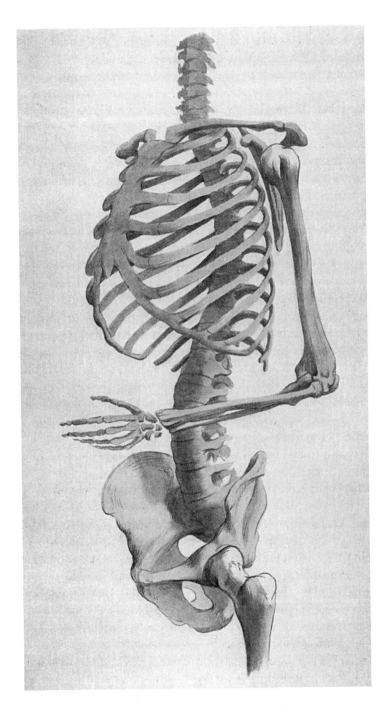

FIG. 2. THE SKELETON FROM THE SIDE

13

INTRODUCTION

The curved surfaces between the outlines are thrown more or less distinctly into relief by the effect of light and shade. As a beginner the student would do well to place himself in such a position that the model receives about two-thirds of light to one-third of shadow. Avoid sitting where the light falls directly on to the model, because without strong relief the modelling of the forms is not clearly indicated and the outline is too predominant, with the result that the beginner traces these edges without understanding. When the student has had more experience, on the other hand, he should try not to be too dependent on the effects of light and shade, and it may even be good training for him then to avoid the treatment of chiaroscura in his work and experiment with pure line.

Proportion is the comparative relation of one form to another. This is not achieved by measuring the separate dimensions of the outline of the forms, but by emphasizing the relative values of the masses. Proportions or relationships are achieved by thinking in three dimensions. By comparing one form with another adjacent to it, working outwards step by step from the change of light to dark, the student will arrive at a truer judgment of the outline bounding the forms.

The skeleton which forms the foundation or substructure of the body is composed of a number of separate bones connected together at the joints by ligaments. These bones may be grouped into four sections: the trunk, the head and neck, the upper, and the lower limbs. The trunk consists of the pelvic girdle of the hips, the rib cage or thorax, and a central vertebral column which extends from the hips to the base of the skull. The skull, which includes the cranium and the bones of the face, rests upon the upper vertebrae or neck of the spinal column. The limbs are connected through two bony girdles to the trunk, the arms through the shoulder girdle and the legs through the pelvic girdle. The bony framework of the skeleton determines substantially the length, breadth and depth of the body.

The bones supporting the limbs are long and cylindrical; the bones which protect the cavities of the body, such as the cranium, the shoulder blades and hip bones, are broad and flat. The hands and feet are constructed upon a number of relatively small, short bones. The substructure of the face is made up of several irregularly shaped bones. Much of the skeleton is obscured by the overlying muscles and by the presence of fat. Some of the bones, however, lie nearer to the surface and these, where they become superficial, determine the modelling of the forms. The forehead, for instance, the wrist, knee and ankle joints, all possess to some extent the qualities of solidity and strength which contrast with the softer and changeable, muscular forms of the cheeks, neck, abdomen and hips, and the fleshy forms which surround the shafts of the limbs. Whether the bony parts are superficial or deep-seated the student should at all times study the skeleton in relation to the surface forms.

The muscles act upon the bones as upon levers, the joints forming the hinges connecting the separate bony parts. While some of the joints are almost fixed the

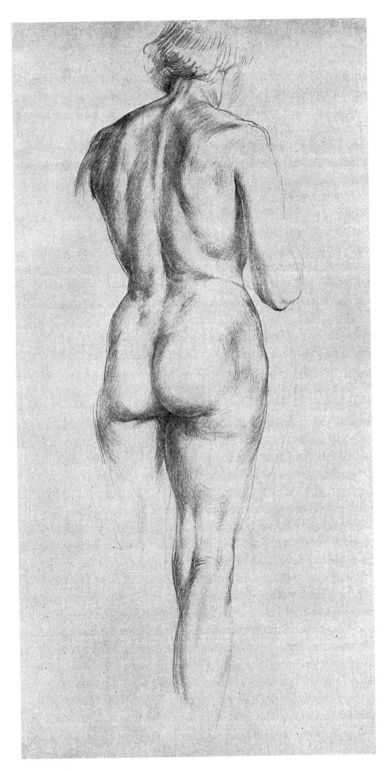

FIG. 3. STUDY OF THE BACK OF A WOMAN
Compare this drawing with Fig. 1

majority of them possess a wide range of movement. Movement is brought about by the contraction of the muscular fibres. When a muscle is in a state of relaxation it is extended and soft and then its borders blend with the other adjacent muscles; when it contracts it becomes hard, broad and shorter, and its outlines then become more clearly defined. Muscular action first presses the surfaces of the joints together, and then moves the bone. One co-ordinated movement involves many muscles. For example, when the biceps of the upper arm comes into action so as to raise the forearm, the triceps muscle at the back of the upper arm relaxes to allow freedom for this movement. When the forearm is forcibly extended backwards the triceps comes into action, and then the biceps muscle is relaxed.

The muscles of the body are arranged in layers upon the skeleton. The individual muscles vary very considerably in size and structure, and in the manner of their attachments. The deeper muscles are usually short, while those nearer the surface are, generally speaking, long and often extend over two, and sometimes three, joints. The majority of muscles are attached at both ends to the bony parts of the body; but there are some, as for instance the facial muscles, which are attached only at one end to the bony parts, the other end being inserted into the skin. The origin of attachment is that ending nearer to the centre of the body; that of insertion is farthest from this centre.

No individual muscle is symmetrical in itself. The muscles connected with the soft tissues of the skin are the simplest in form and structure. The majority of muscles are extremely complicated in their shapes. Many muscles are triangular, while some are long and ribbon-shaped, and again others are short and rounded.

All muscles which are attached to the bony parts are provided with tendons. These tendinous endings are inelastic and inextensible. Tendons of origin are usually broad; those of insertion are more often long and flattened, and sometimes they are divided so as to connect with several bones such as in the hand and foot, where the common extensor muscles reach to the extremities. On the trunk the tendons are flat, broad and thin. Many tendons are as long or even longer than their fleshy parts.

The muscles are invested by a membranous sheath called the deep fascia. This fascia covers almost the entire body, surrounding the muscles, bracing and supporting them in action. The superficial fascia connects the deep fascia with the skin. The fat of the body is contained in the superficial fascia. Though the amount of fat within this connective tissue varies considerably in different parts of the body, it tends to accumulate more or less upon the abdomen and chest muscles, over the hips, and upon the thighs. The presence of fat in these regions obscures the irregularities of the bony and muscular forms beneath. Particularly is this so with women whose contours are, generally speaking, fuller and more rounded than the male forms.

THE TRUNK

THE SKELETON OF THE TRUNK

The main structure or trunk of the body includes the rib cage or thorax; the pelvic girdle and the vertebral column which supports and links these two forms together.

The thorax is a barrel-shaped form composed of twelve pairs of ribs which are attached behind to the vertebral column and curve forwards and downwards. The upper seven ribs are attached in front to the breastbone or sternum. The eighth, ninth and tenth join in front with the ribs immediately above, forming the thoracic arch. The eleventh and twelfth pairs of ribs are unattached in front to the cartilages above, and are consequently called floating ribs. The whole truncated cone of the thorax is broadest about its lower half.

The pelvic girdle consists of two hip or innominate bones fixed to the lower part of the backbone. On the outer side of each of these pelvic bones is a cup-shaped cavity for the head of the thigh bone to fit into. This cavity is called the acetabulum. The pelvic part above and partially behind the acetabulum is called the ilium, the lower part beneath this cavity is called the ischium, while in front lies the smallest part of the innominate, the pubic part.

The vertebral column is built up of thirty-three or sometimes thirty-four vertebrae, each joined to the next by intervertebral discs. The column in an adult is developed into four curves; the cervical in the neck convex forwards, composed of seven vertebrae; the dorsal in the back, concave forwards, consisting of the twelve vertebrae to which the rib shafts are attached; the lumbar curve of five large and relatively free vertebrae, again bulging towards the front; and the sacral, composed of five vertebrae fused together. The coccyx, composed of the remaining three or four vertebrae, is completely hidden in the human figure.

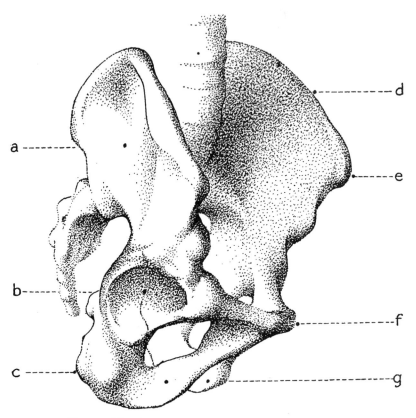

FIG. 4. THE PELVIC GIRDLE FROM THE RIGHT SIDE
a. Ilium
b. Acetabulum
c. Ischial tuberosity
d. Iliac crest
e. Anterior superior spine
f. Pubis
g. Ischium
h. Posterior superior spine
i. Sacrum
j. Coccyx

THE MOVEMENTS OF THE TRUNK

Only small movements can take place between the individual vertebrae. Added together they bring about the bending and torsion of the spinal column which cause the gross changes seen in the form of the trunk when the body assumes different attitudes. The range of movement of the several divisions of the spine, cervical, dorsal or lumbar, varies considerably. Nodding movements of the head are caused by the skull

rocking on the upper end of the spine, whilst side to side wagging movements occur between the first two cervical vertebrae. Below this level the freest movement of the neck is lateral bending, so that a man can almost lay his head upon his own shoulder. Forward and backward bending and rotation are much more limited in this region.

In the thoracic part of the spine lateral bending is very much restricted by the ribs on each side, and forward flexion only takes place over a small range for the same

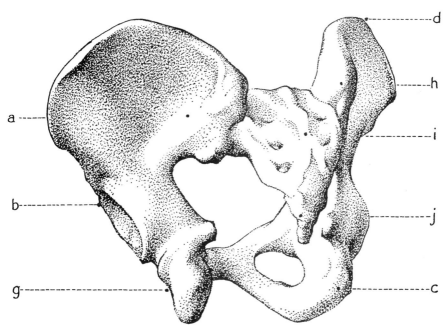

FIG. 5. THE PELVIC GIRDLE FROM THE BACK
See key to Fig. 4

reason. The freest movement in the thoracic region is curiously enough rotation. This, and the great freedom of movement which is possible in the lumber spine are two facts which are of most importance to the artist. The thorax sits on the lumbar spine like a tulip upon its stalk, the bulb being represented by the pelvic girdle below. And, like a tulip, the thoracic mass almost waves about its stalk projecting upwards from the great pelvic mass below. This is the key to the changes in shape which take place in the movements of the trunk.

In bending forwards, the backward concavities in the cervical and lumbar regions flatten out and the whole spine becomes one continuous curve from the skull to the pelvic girdle. In backward bending the vertebrae of the neck and lumbar region move more than those in the thoracic area. In lateral bending the lower border of the thorax approaches very close to the crest of the ilium. The amount of rotation which

can take place is clearly evident in the angular shift of the line joining the points of the shoulders in comparison with the transverse axis of the pelvis.

In all these movements the centre of gravity of the body is displaced and in order to maintain equilibrium and ensure that the weight passes downwards through the soles

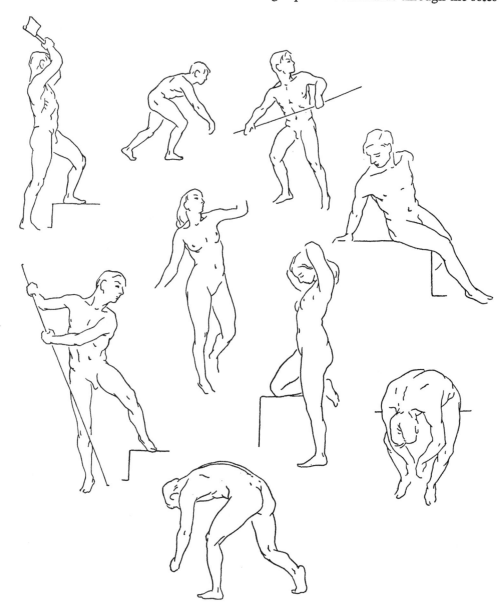

FIG. 6. THE MOVEMENTS OF THE TRUNK

of the feet some adjustment of the pelvis is necessary. In forward bending the legs lean backwards carrying the pelvis in this direction on the top of the thighs; in lateral bending the pelvis sways to the opposite side.

When a man stands on one leg, the other being free with the knee slightly flexed, the pelvis will tilt downwards on this latter side, but at the same time it will be shifted slightly to the supporting leg side to bring the centre of gravity vertically above this foot. The thorax follows this shift and also leans over a little to the supporting side.

We shall notice the effects of these movements on the muscular forms later on. For the moment it is necessary to show how the structures of the trunk adjust their positions so that the weight of the body may be evenly distributed around the central line of gravity. These adjustments that make for the balance of the human figure should help the student in his observation of relationships, and give him a sense of design. Moreover, in his drawing of the human figure he can, if he bears in mind the principles of balance, give to the parts their individual characteristics of rigidity or malleability.

THE MUSCLES OF THE TRUNK

The superficial muscles on each side of the trunk include the pectoralis major, the serratus magnus, the rectus, the external oblique, the erector spinae, the trapezius and the latissimus dorsi. The rhomboids major and minor, and the levator scapula, though these muscles are deep-seated, have been included for description because they have considerable influence on the contour of the shoulder.

The pectoralis major is a thick, broad, triangular muscle, the base of which originates from the inner half of the collarbone or clavicle, from the sternum, and from some of the rib shafts. The fibres of this muscle converge outwards towards the arm where they form the thick anterior border of the armpit. The muscle is inserted by a flattened tendon into the upper arm bone or humerus.

The serratus magnus is a thick, broad muscle which arises by a series of pointed digitations from the upper eight rib shafts. These digitations are arranged in crescentic fashion on the side of the thorax below the armpit. Passing backwards under cover of other muscles, the fibres of the serratus magnus converge under the shoulder blade and are finally attached to the vertebral border of that bone.

The rhomboids, major and minor, originate from the lower cervical and upper dorsal spines, and are attached to the vertebral border of the shoulder blade.

The levator scapula, attached above to the upper neck vertebrae and below to the upper angle of the shoulder blade, also lies deep.

The recti muscles extend the whole length of the abdomen in two long, flattish muscular forms separated by a tendinous band or abdominal furrow descending down the middle of the trunk. Each muscle arises from the fifth rib shaft and from the lower rib cartilages; covering these bones by thin tendinous portions, it extends over

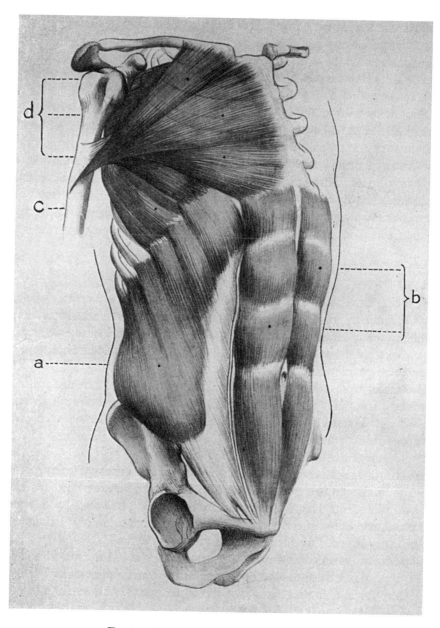

FIG. 7. THE MUSCLES OF THE TRUNK
a. External oblique
b. Recti
c. Serratus magnus
d. Pectoralis major

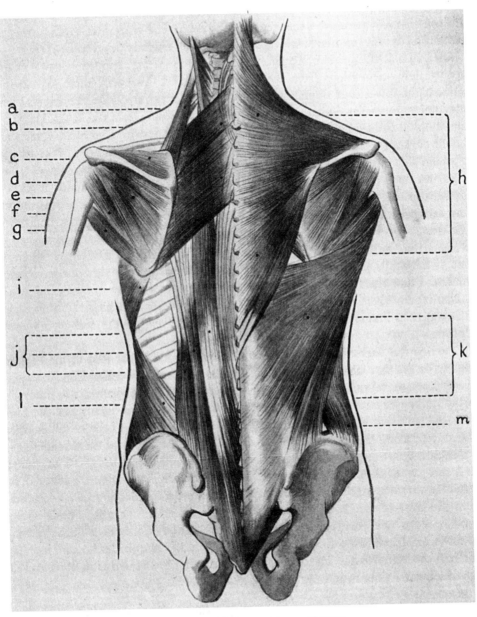

FIG. 8. THE MUSCLES OF THE TRUNK

a. Levator scapula
b. Rhomboid minor
c. Supraspinatus
d. Rhomboid major
e. Infraspinatus
f. Teres minor
g. Teres major
h. Trapezius
i. Serratus magnus
j. Erector spinae
k. Latissimus dorsi
l. Internal oblique
m. External oblique

the thoracic arch down to the pelvis to be inserted into the pubic part of the girdle. The muscle is divided across into segments by three tendinous intersections, one near the umbilicus and two above which curve upwards towards the median furrow.

The external oblique is a broad, superficial muscle situated in the loins. It originates by fleshy digitations from the lower eight ribs, the upper three slips arising between the lower four digitations of the serratus magnus, while the origins of the three lowest muscular digitations are covered by a muscle from the back. This interdigitation on the side of the thorax is apparent in some degree on most models and should be recognized as muscular endings and not as surface indications of the ribs to which they are attached.

To the front of the body the external oblique passes into a flattened tendon or aponeurosis. Towards the middle line it forms the outer wall of the rectus muscle. The external oblique is inserted below into the outer surface and front half of the iliac crest.

The erector spinae muscles extend from the sacrum and ilium of the pelvis to the base of the skull, and form two muscular masses one on either side of the vertebral column. From their tendinous and pointed attachments below they ascend to the lumbar region where they appear larger and thicker. Before reaching the thorax each muscle divides into two parts and continues thus upwards into the neck by numerous processes.

Covering the back of the neck, the shoulders and the upper part of the back are the two large, flat, triangular trapezius muscles. The muscle arises from the spines of the dorsal vertebrae, from the seventh cervical spine, from ligaments in the region of the neck, and from the back of the skull. From these extensive origins the fibres converge outwards to be inserted at the back along the spine of the shoulder blade, and in front along the outer third of the collarbone to the points of the shoulder.

The latissimus dorsi is almost entirely superficial and covers the lower part of the back and part of the sides of the trunk. This muscle originates from the lower dorsal vertebrae where it is covered by the trapezius, from the lumbar and sacral vertebrae, from the crest of the ilium and from the lower three or four ribs. The latissimus dorsi is for the most part thin, but it becomes thicker and fleshier as its fibres converge upwards and outwards to form the posterior fold of the armpit. As it nears its insertion into the humerus the muscle twists upon itself. The two latissimi dorsi muscles together form a sling round the lower part of the back.

Surface Forms of the Trunk

Fig. 9. The greater part of the outer surfaces of the pelvic bones is covered by muscles and fat. The outer margins of the iliac crests are disclosed by furrows which run for a short distance along either side of the hips. From behind, the junction of the pelvic

SURFACE FORMS OF THE TRUNK

bones to the sacrum can be distinguished by two depressions on either side of the triangular form of the sacrum. The positions of these pelvic points can be recognized throughout all movements of the body, and the artist can make good use of their constant mutual relationships, for they provide a sure basis upon which to construct the fleshy forms surrounding them.

Lying beneath the thinner parts of the latissimi dorsi muscles the erector muscles appear in the loins as a convex prominence; about the middle of the back they become narrow, flatten and gradually subside. Covered above by the trapezius muscles, their extensions emerge again in the neck as two prominent ridges widening upwards to the back of the skull.

The latissimus dorsi coming from the crest of the ilium can be seen passing upwards and forwards round the angle of the shoulder blade to reach the arm. In this position of the body the surface form of the latissimus dorsi shows moulding due to the lower ribs.

The trapezius can be traced inwards from the point of the shoulder, along the spine of the shoulder blade, over the vertebral border of this bone, downwards towards the spinal column. When the trapezius is relaxed, as illustrated here, the muscles underlying it, the erector spinae, the rhomboids and the levator scapulae, all clearly influence the surface planes. At the base of the neck the oval depression round the seventh vertebra, formed by the tendinous parts of the two trapezius muscles, is easily observed.

The position chosen to illustrate the surface forms of the back shows the trunk bent forward from the pelvic girdle. The muscles are relaxed. Ask the model to assume this position. A lean muscular type should best illustrate the anatomical points. Now ask him to bring his back slowly into the erect position with the shoulders straightened. Get him to move slowly forwards and backwards so that the movement from the one position to the other is understood. Movement can only be understood if the body be observed changing from one closely related position to another, rather as we look at a slow-motion film. Every attitude of the body is one of arrested movement. If movement is to be interpreted in drawing the artist must understand the positions prior to and following after the one which the model assumes. This applies to all so-called action poses which are simply arrested attitudes in the sequence of many positions which go to make up the movement. In an upright, evenly balanced position, as also in a reclining one, the body is poised or in a state of rest.

If the trunk is brought into the erect position with the shoulders drawn back, considerable changes will be noted. The lower vertebrae of the lumbar region will now curve forwards and their spinal projections will disappear between the erector muscles which will have contracted on either side of the spinal column. Seen from the back the concavity of the lumbar curve will be apparent, but from the side their curve will be obscured by the muscular ridge of the erector muscle.

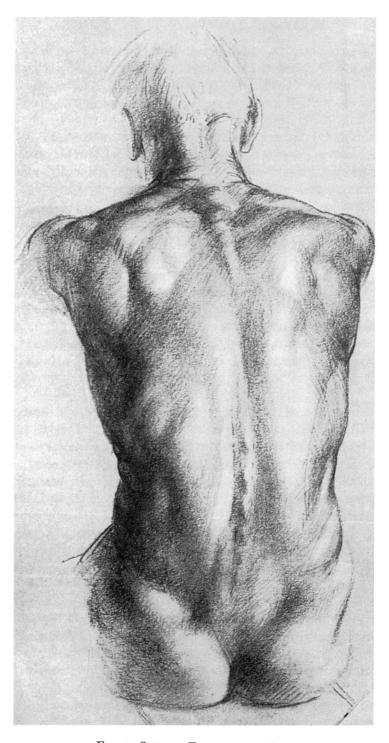

FIG. 9. SURFACE FORMS OF THE BACK

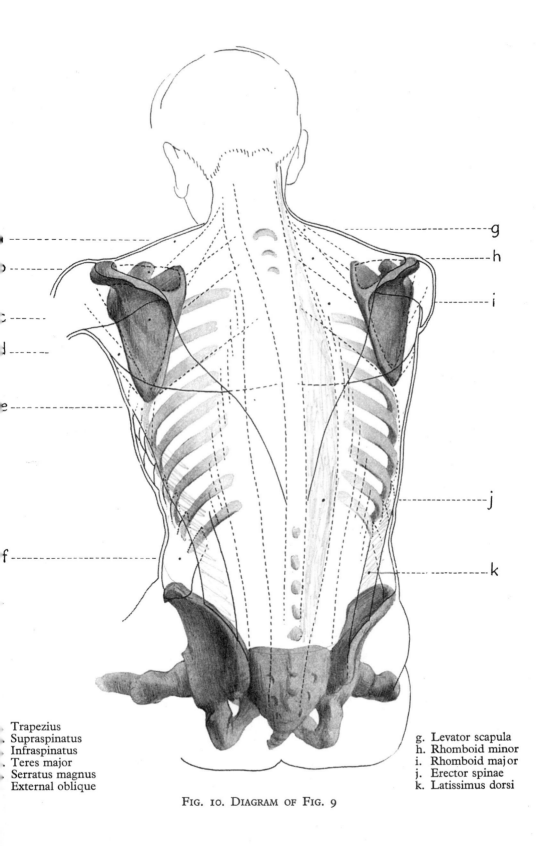

g

h

i

j

k

Trapezius
Supraspinatus
Infraspinatus
Teres major
Serratus magnus
External oblique

g. Levator scapula
h. Rhomboid minor
i. Rhomboid major
j. Erector spinae
k. Latissimus dorsi

FIG. 10. DIAGRAM OF FIG. 9

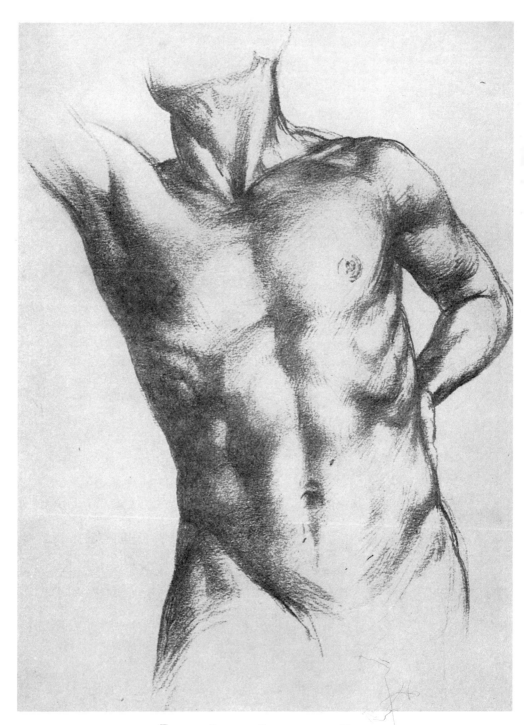

FIG. 11. SURFACE FORMS OF THE FRONT

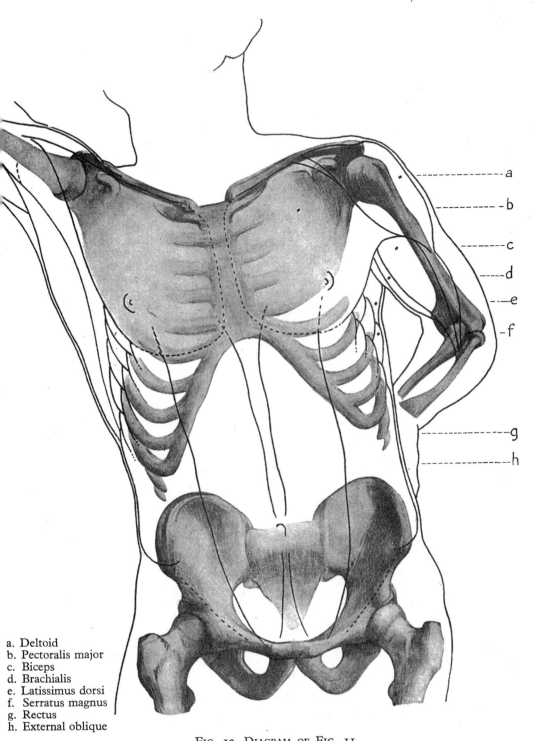

a. Deltoid
b. Pectoralis major
c. Biceps
d. Brachialis
e. Latissimus dorsi
f. Serratus magnus
g. Rectus
h. External oblique

FIG. 12. DIAGRAM OF FIG. 11

THE TRUNK

The prominent vertebra at the base of the neck will still be seen, but the muscular forms surrounding it will alter considerably, closing in around it in a fleshy mass. The outer or vertebral borders of the scapular bones, indicated in the illustrated position by furrows, will now be apparent as raised forms closer in to the spinal column. The trapezius will assert its cowl-like shape over the shoulders.

Probably the most obvious effect of straightening the back will be the concealment of the thoracic form which is so clearly seen when the body is slumped forwards. The moulding of the lower rib shafts will no longer be seen and, superficial to the latissimi dorsi, oblique folds will appear on the surface directed downwards from the lower dorsal spine towards the iliac crests. The further the thorax leans backwards, increasing the lumbar curve, the more prominent these oblique folds on the lower surface forms of the trunk will become, and finally altogether conceal the structures beneath their fleshy masses.

Fig. 11. Respiratory movements cause the thoracic wall to expand and contract, and lateral movements tend to compress the ribs on the one side and slightly separate those on the other. For the purposes of drawing, however, the thorax may be taken as a fixed form that can only change its position as a whole as the vertebral column leans either forwards or backwards, to either side or rotates. Any of these movements will naturally vary the shape of the muscles attached to the rib wall, but the underlying structure which provides positions for these attachments will maintain the same relationships throughout.

The three planes corresponding to the component parts of the sternum, and the rib cartilages that connect to this bone, impart a general convexity to the upper part of the chest. The large pectorals are almost entirely superficial, though overlaid by a certain amount of fat; well developed, as in this illustration, the pectorals hide the ribs, though the rounded form of the thorax beneath them is apparent in the general surface modelling of these muscles.

Below the pectoral muscles the muscular attachments of the serrati muscles and the external obliques only thinly cover the rounded forms of the rib shafts. The shape of the recti are subordinate above to the prominently curved form of the thorax. As these muscles descend over the thoracic arch they become more easily distinguished as two muscular forms separated from the loins by the aponeurotic grooves of the external oblique muscles on either side. Below the navel the recti narrow but, owing to the presence of ligaments passing from the anterior superior spine of the pelvic bones towards the pubic arch, the surface effect is of one broad convexity concurrent with a curved line connecting these pelvic points. The interdigitation between the serrati muscles and the external obliques can be seen on the sides of the rib wall.

When the trunk is inclined sideways considerable changes occur in the surface modelling of the external oblique muscles and in the recti. Excepting for the lumbar

vertebrae there is no bony structure in the waist to interfere with the movements of the body, and consequently these muscles are of great importance to the drawing of the trunk in certain movements. If the body is bent over sideways from the erect position, a transverse section of the thorax no longer lies parallel to a plane resting upon the crests of the iliac bones. The surface effect is to compress the external oblique on the one side and to stretch it on the other. The recti muscles also will exhibit certain variations of surface modelling on either side of the median furrow.

If movement can be suggested at all in drawing the human body it should be possible to do so by studying the changes in surface modelling as the obliquely disposed thorax returns to a position in which its cross section lies again parallel with a plane resting upon the tops of the crests of the iliac bones. By studying these modifications, the gradual alteration of direction and the subtle changes of form in the muscles surrounding the waist, the artist may be able to suggest that sequence of change from one position to another which we call movement.

Fig. 13. The oval shape of the thorax is apparent in this illustration lying beneath the muscular forms. The moulding of rib shafts can be seen in the lower part of the back. In the front of the figure the left side of the thoracic arch can be traced, and it becomes especially clear as it passes beneath the thin aponeurosis of the external oblique. The curvature of the vertebral column is obscured by the thoracic curve above, and by the ridge of the erector muscles below. The upper part of the trapezius can be seen extending outwards from the neck to the point of the shoulder. A ridge below this muscle indicates the spine of the shoulder blade. The arm being drawn forward, the blade is swung downwards, outwards and forwards. This position of the bone is shown by the increased obliquity of its spine and by the direction and prominence of its vertebral border. The surface of the blade is covered by several short muscles extending between this border and the upper arm bone. The lower muscles of this scapular group are partially covered by the upper border of the latissimus dorsi; this is faintly indicated. Below the latissimus dorsi, and directly below the shoulder in this drawing, a thick fold can be seen arising from the lower rib wall and ascending in a prominent curve to the armpit; this is caused by the thick muscular serratus magnus which is in action and therefore contracted. Below the serratus magnus the digitations of the external oblique appear, rather thinly covering the surface of the lower ribs. Descending over the thoracic arch the anterior border and the aponeurosis of the external oblique clearly separate this muscle from the rectus in front, while its lower attachment discloses the obliquity of the iliac crest.

Suppose now that the illustrated figure were to lean to his left side. In some degree the following changes would take place. The fleshy bulk of the external oblique, being contracted, would bulge more prominently over the crest of the hip bone, and the oblique fold we noticed in the erect position of the back would be seen directed downwards and forwards from the lower dorsal spine, continuing with the fleshy mass of

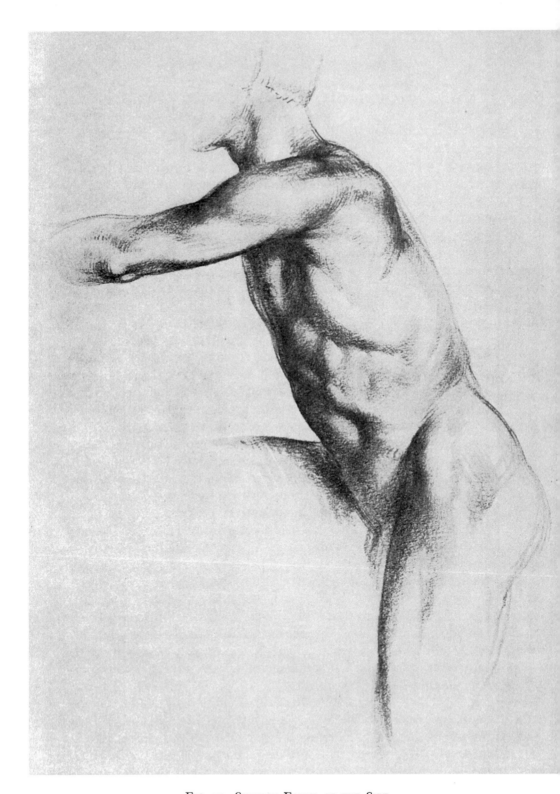

FIG. 13. SURFACE FORMS OF THE SIDE

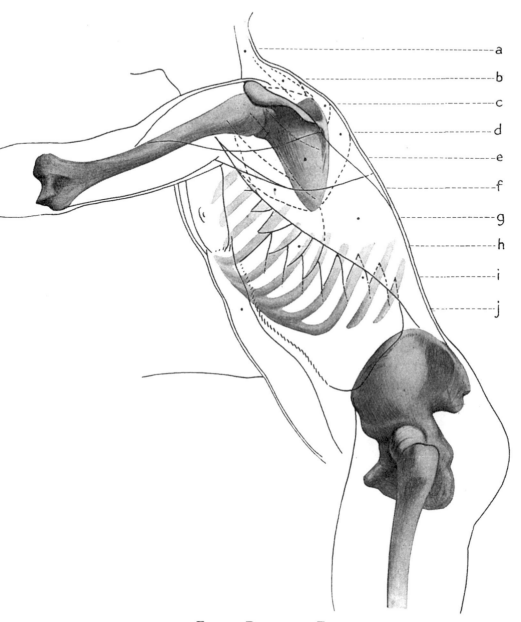

FIG. 14. DIAGRAM OF FIG. 13

a. Trapezius f. Teres major
b. Levator scapula g. Latissimus dorsi
c. Rhomboid minor h. Serratus magnus
d. Rhomboid major i. External oblique
e. Infraspinatus j. Rectus

the external oblique towards the iliac crest. The lower rib shafts would be obscured, and the hollow beneath the thoracic arch would disappear as the muscles contracted to draw the thorax over to the left side.

Now get the model to lean away to his right side. The left external oblique muscle would relax and flatten and the crest of the hip bone, instead of being indicated, as in the illustration, by an oblique furrow, would be seen as a projection, the curvature of the crest becoming traceable to its anterior superior spine. The modelling of the pelvic girdle, apart from the now prominent ridge of the iliac crest, would remain relatively unchanged. The upper part of the body, in contrast, would be seen in perspective, with the circular barrel-shaped form of the thorax becoming more evident.

2

THE HEAD AND NECK

THE SKELETON OF THE NECK

The skeleton of the neck is composed of the seven cervical vertebrae of the spinal column. The upper two vertebrae carrying the skull are named the atlas and the axis. The atlas is the uppermost; through its peculiar formation and attachment to the base of the skull the nodding movements of the head are made possible. Rotatory movements of the head are produced by the articulation of the atlas with the axis. The seventh vertebra at the base of the neck is prominent, but the remaining cervical vertebrae lie deep in the groove between the erector spinae muscles which extend upwards to the back of the skull.

From the front the cervical vertebrae are absolutely hidden by muscles and other structures of the neck. Situated in front of the vertebrae and beneath the chin is a small bone called the hyoid. Directly below this bone lies the thyroid cartilage or Adam's apple which is always fairly prominent. The thyroid gland suspended below and on either side of the thyroid cartilage is usually larger in women, giving a more rounded appearance to the base of the neck. The trachea or windpipe, composed of a series of ringed cartilages, descends through the lower part of the neck into the thorax.

THE MUSCLES OF THE NECK

The muscles of the neck include the upper part of the trapezius, the sterno-mastoid, a triangular group between these muscles, an anterior group, and a thin covering called the platysma.

The forms of the back and part of the sides of the neck are dependent on the deep muscles of the back and upon the trapezius covering these muscles.

35

THE HEAD AND NECK

The sterno-mastoid bordering the throat is a large, thick muscle originating from the base of the neck by two heads. The inner or sternal head is attached to the manubrium, the upper part of the sternum; the outer clavicular head is attached to the inner part of the clavicle. These two heads of origin join about the middle of the neck and ascend as one muscular mass to be inserted by a broad tendon into the mastoid protuberance behind the ear.

The triangular space between the sterno-mastoid and the trapezius contains parts of muscles arising from the back and shoulders. These muscles are not apparent as separate forms on the surface of the neck, though as a group they form a slight depression between the sterno-mastoid and trapezius muscles. If the shoulders are drawn forwards this depression deepens and then the sterno-mastoid and the border of the trapezius stand out clearly.

The anterior muscles of the neck are subdivided into two groups; those above the hyoid bone running up to the lower jaw, and those below this bone descending over the cartilages of the larynx and thyroid gland. These muscles are all thin and flat.

The platysma is a thin, superficial sheath lying in the fatty covering of the neck. Arising from the fascia which covers parts of the chest and shoulders, the platysma passes upwards, joining with the fasciculi of the opposite side. It is inserted into the lower part of the face, mingling there with the muscles at the angles of the mouth.

SURFACE FORMS OF THE NECK

The sides of the neck are determined by the elevated borders of the trapezius, and by the sterno-mastoid muscle. The sterno-mastoid is clearly visible as a ridge running from behind the ear obliquely downwards and forwards to the front and base of the neck. From the front the outline of the neck is defined by this muscle with the ridge of the trapezius ascending behind it. The two separate attachments of the sterno-mastoid can be clearly distinguished when the head is turned towards the opposite side, when this muscle will come into action. When the head is facing forwards the muscle is relaxed and the two heads of origin together give a flattish plane bordering the upper part of the collarbone. Between the sterno-mastoid and the trapezius lies the triangular hollow occupied by the deeper muscles surrounding the neck. Though this depression is always slightly apparent it is to a great extent obscured and flattened by the platysma covering it, and also by the presence of a certain amount of fat.

To the front of the neck, if the head is thrown back, the general structures of the throat are plainly indicated, being little influenced by the anterior group of muscles which cover them but thinly. The throat appears convex in its upper half, the structures here protruding in front of the sterno-mastoid muscles which embrace it on either side. In its lower half the throat appears to sink between the two inner heads of the sterno-mastoids.

The Skeleton of the Head

The cranium or brain case consists of several curved plates of bone united by a series of interlocking teeth-like projections. Altogether these bones present the smooth dome-like roof and sides of the cranium. The cranial bones affecting the surface are

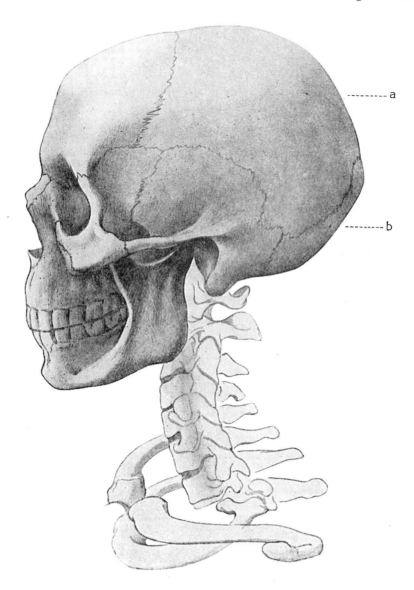

FIG. 15. THE SKULL FROM THE SIDE
a. Parietal bone b. Occipital bone

the frontal, the two temporals, the two parietals and the occipital. The frontal bone occupies the whole of the forehead and part of the roof of the skull. The temporal bones lie one on either side of the cranium in front, above, and behind the ears. The parietal bones together form the upper sides and hinder part of the dome, while the occipital bone forms the back and lower part of the cranium.

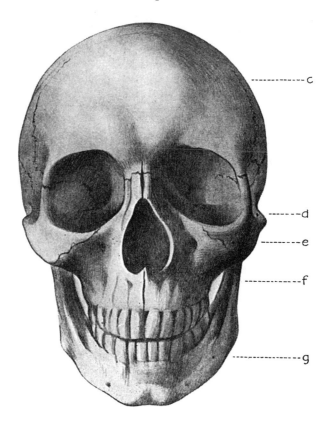

FIG. 16. THE SKULL FROM THE FRONT
c. Frontal bone f. Maxillary bone
d. Zygomatic arch g. Mandible
e. Malar bone

The frontal bone determines the surface forms of the forehead. The other bones of the cranium form together the rounded appearance of the head as a whole. On either side of the upper part of the forehead are rounded elevations called the frontal eminences. Forming the boundary between the forehead in front and the temple at the side is a curved ridge of bone. This is called the temporal ridge. It forms a part of the outer margin of the eye or orbital socket. The superciliary ridges form the bony prominences of the brows directly above the upper margins of the orbital sockets.

THE SKELETON OF THE HEAD

The bones of the face consist of two malar or cheek bones, two nasal bones, two maxillary bones forming the upper jaw, and the mandible or lower jaw. The malar bone, underlying the prominent part of the cheek, is irregularly quadrilateral in shape, and is composed of a central thick plate of bone with three narrow projections, one running upwards, one backwards and one forwards. The central part of the malar bone is broad, unevenly convex, and very prominent on the outer side of the face. The spur extending upwards ascends to join with the temporal ridge above, thus completing the outer orbital border. The posterior extension passes backwards to join with a correspondingly narrow part of the temporal bone; together these narrow bony extensions form the zygomatic arch, a prominent feature which bridges the temporal hollow and unites the cranium with the face.

The two small nasal bones are united above with the frontal bone. They are joined together along the middle line, forming the bridge of the nose, slightly hollow above but convex below. The lateral borders of these bones rest on the maxillae or upper jaw bone. Their lower borders are free and form the upper part of the nasal opening. These nasal bones are only thinly covered by muscles, thereby displaying the characteristic form of the bridge of the nose.

The two large maxillary bones together form the upper jaw. These two bones meet below the aperture of the nose. The greater part of their lateral surfaces are concealed beneath the fullness of the cheeks. Each maxillary bone is united above to the frontal and to the nasal bones. It is joined on its outer edge with the malar bone and forms, above, the inner and lower border of the orbital socket. The concave form of the maxilla below the lower orbital margin is often revealed by the falling in of the soft parts of the cheek. The lower united surfaces of the maxillary bones form together the convex contour which determines the general form of the upper part of the mouth.

The mandible or lower jaw bone is also convex forwards, giving the curved substructure upon which the lower part of the mouth rests. Generally speaking the dental arch of the maxillae projects a little beyond that of the mandible, and consequently the upper front teeth slightly overlap the lower ones. The lower and outer borders of the mandible are thick and rounded. The lower front border becomes thinner and presents a triangular elevation which forms the point of the chin. The mandible, extending backwards from the chin, becomes continuous on either side with the two rami, whose flattened upturned ends are received into the glenoid cavities of the temporal bones. The junctions of the main part of the mandible with the rami show, on either side, the rounded corners or angles of the lower jaw.

THE EYE

The globe of the eye maintains a position in front of the orbital socket, rather nearer to the upper than to the lower border. The eyeball is a small spherical camera about

one inch in diameter, and is made up of one large segment with a smaller segment affixed to it in front. The larger segment corresponds to the white of the eyeball, the sclerotic; the smaller segment represents the cornea. The cornea is transparent and slightly prominent upon the eyeball. Looking through the clear surface of the cornea we see the iris, a beautiful multi-coloured membrane in the centre of which is the circular opening or pupil of the eye. The pupil becomes contracted or dilated according to the amount of light admitted into the eyeball.

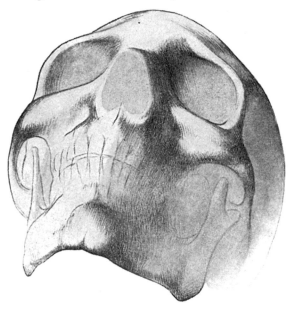

FIG. 17. THE SKULL TILTED BACKWARDS

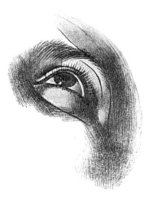

FIG. 18. THE EYE AS IT WOULD APPEAR IN FIG. 17

THE EYE

The surfaces of both the cornea and the sclerotic, being kept continually moist by the secretion of tears, reflect, as in a mirror, the luminous objects within the sphere of vision. These glinting high lights are particularly bright on the surface of the cornea against the dark background of the iris; this effect is further heightened by the blackness of the pupil and also by the shadow cast on the eyeball by the upper lid.

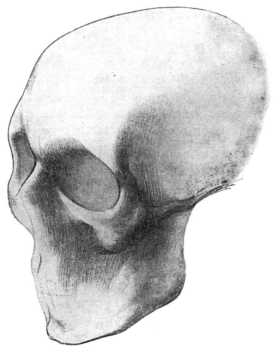

FIG. 19. THE SKULL, THREE-QUARTER VIEW

FIG. 20. THE EYE IN PROFILE
showing the boney formation underneath

41

THE HEAD AND NECK

THE EYELIDS

The eyelids, resting upon and following the curvature of the eyeballs, are of a perceptible thickness. They are attached by ligaments to the walls of the orbit. The upper lid is larger than the lower and is continuous with the skin of the eyebrow. The lower lid is continuous with the skin of the cheek. When we speak of the size and shape of the eye we refer to the amount of the eyeball which is visible through the aperture between the upper and lower lids. In some faces this space is constricted at the corners and is small, while in others the opening is wide and the eye therefore appears large. The corners of the opening lie approximately within a horizontal plane, the outer corner being slightly higher than the inner one. In the Mongolian type of face this elevation of the outer corners is very marked and the eyes therefore appear to be almond-shaped. The eyelids meet at the outer corner at an acute angle. At the inner corner between the lid margins is a small elongated recess which slants inwards towards the nose. Within this recess lies a very small fold of skin which can be seen clearly if the eye is directed outwards away from the nose.

If the eyes are directed upwards the cornea becomes partially covered by the upper lid and the additional curve of its segment upon the eyeball slightly raises the contour of the upper lid as it passes over the cornea. If, while still looking upwards, the eyes are directed to one side, different parts of the two upper lid curvatures are increased accordingly.

THE MUSCLES SURROUNDING THE EYE

These muscles include the occipito-frontalis of the scalp, the corrugator muscle lying between the eyebrows, and the orbicularis covering the orbital socket and eyelids.

The cranium is covered by four muscles, the occipitales and the frontales which are united by a wide aponeurosis. The frontalis muscle is superficial upon the forehead. Bordered by the temporal ridges, it descends to the orbital borders, blending here with the corrugator muscle and with the orbicular muscle surrounding the eye. The frontales elevate the eyebrows; by this action the skin of the forehead is creased into transverse folds and furrows. The occipital muscle is situated at the back of the head upon the occipital bone and is covered by the scalp.

The corrugator muscle between the eyebrows is covered by the frontales and by the orbicular muscles. By the action of the corrugator the brows are contracted inwards and forwards to provide a shield over the eyes, thus helping to protect them from excess of light. This muscle is also brought into action by emotional or mental strain and, with age, permanent vertical furrows are often to be seen in the skin between the eyebrows.

The orbicularis muscle surrounding the eye is a thin muscular sheet. Elliptical in

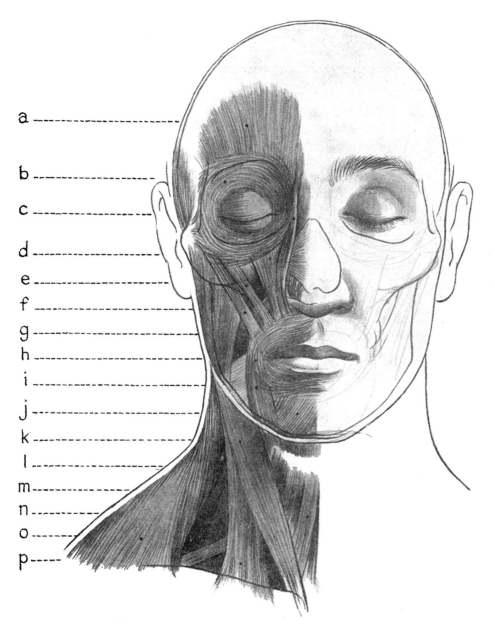

a ------------------

b ------------------

c ------------------

d ------------------

e ------------------

f ------------------

g ------------------

h ------------------

i ------------------

j ------------------

k ------------------

l ------------------

m ------------------

n ------------------

o ------------------

p ----

FIG. 21. THE MUSCLES OF THE HEAD AND NECK FROM THE FRONT

a. Frontalis
b. Orbicularis of eye
c. Levator of nostril and upper lip
d. Levator of upper lip
e. Zygomaticus minor
f. Zygomaticus major
g. Buccinator
h. Orbicularis of mouth

i. Depressor of angle of mouth
j. Depressor of lower lip
k. Sterno-mastoid, inner
l. Thyrohyoid
m. Omohyoid
n. Sternohyoid
o. Trapezius
p. Sterno-mastoid, outer

shape, it overlaps the margins of the orbital socket and covers the eyelids. This muscle is used to narrow or close the aperture of the eyelids. Radiating folds or 'crows' feet', caused by the contraction of this muscle with laughter and other expressions, often become permanent wrinkles in the skin on the outer sides of the eyes.

THE MUSCLES OF THE NOSE

The muscles of the nose include the pyramidal muscle, the compressors, the dilators and the depressors of the nostrils, and the levators of the nostrils and upper lip.

The pyramidal muscle is superficial upon the bridge of the nose and continuous with the frontalis muscle above. When the pyramidal muscle is contracted transverse furrows are noticeable across the root of the nose.

The lower framework of the nose is formed by small cartilages. Arising from the maxillary bones and covering the upper cartilages the compressor muscles lie, one on either side of the nose. These muscles are united above and blend with the pyramidal muscle. The dilators are minute muscles situated obliquely downwards and forwards one on either side of the nostrils. The short depressor muscles are superficial on either side between the nostrils and the cheeks. The levator muscles are long and thin, and they lie superficially downwards and slightly outwards between the nose and the cheeks.

THE MUSCLES SURROUNDING THE MOUTH

The soft and mobile form of the human mouth renders it one of the most characteristic and often one of the most beautiful features of the human face. The lips are composed of interlacing muscular fasciculi with membranous covering. The skin, adhering loosely to their forms, is very thin. Being composed of completely soft tissue the lips can be moved very rapidly by the numerous muscles surrounding them, and are capable of much subtlety of expression.

The muscles surrounding the mouth are: the levators of the upper lip, the levators of the angles of the mouth, the zygomatic muscles, major and minor; the depressors of the angles of the mouth, the depressors of the lower lip, the levator of the lower lip, the orbicularis of the mouth, the risorius and the buccinator.

The levator of the upper lip is thin, flat and square. Originating from the maxillary and malar bones, it descends almost vertically to be inserted into the orbicularis above the upper lip.

The levator of the angle of the mouth is a short, thick and deep-seated muscle. Originating from the maxillary bone it passes obliquely downwards and forwards to blend at the corner of the mouth with the orbicularis.

The zygomaticus minor is an elongated muscular bundle. It takes origin from the

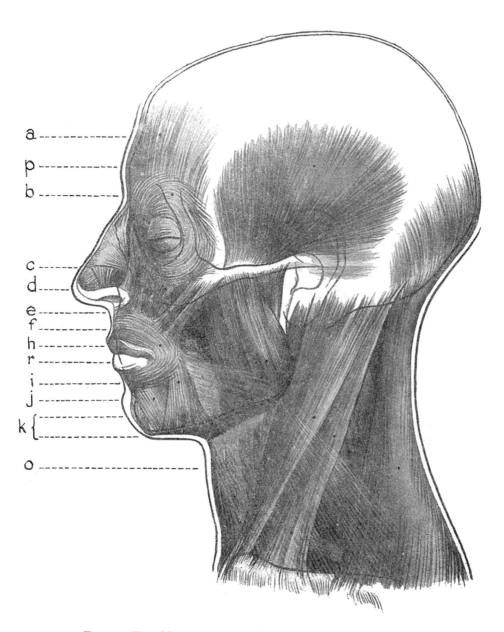

FIG. 22. THE MUSCLES OF THE HEAD AND NECK FROM THE SIDE
See key to Fig. 21

45

malar bone and descends obliquely downwards, forwards and inwards towards the angle of the mouth. This muscle with the levator of the upper lip and the levator of the nostril and upper lip may be regarded as one muscle possessing three heads of origin and one common insertion, since these three muscles always act together.

The zygomaticus major originates from the malar bone, but a little to the outer side of the zygomaticus minor. It descends in an oblique direction similar to that of the smaller zygomatic muscle towards the corner of the mouth, blending here with the orbicularis. The zygomaticus major draws the corner of the mouth backwards and upwards as when laughing.

The depressor of the angle of the mouth is flat and triangular. It arises from the lower jaw and is inserted into the tissues at the corner of the mouth. The action of this muscle is to depress the corner of the mouth, giving a dismal expression to the face.

The depressors of the lower lip are quadrilateral in shape, and are situated in front of the chin. Separated below, where they originate from the lower border of the jaw, these two muscles ascend obliquely inwards to meet in the middle line above.

The levators of the lower lip are deep in their upper part but superficial below. As they ascend from the lower border of the jaw they incline inwards and are inserted into the skin of the chin. These small muscles raise and protrude the lower lip, giving expressions of doubt and scorn.

The orbicularis encircling the mouth is a thin muscular sheet similar to that surrounding the eye. The labial part of this muscle, passing uninterrupted round the corners of the mouth, covers the red borders of the lips. The facial part, also disconnected from bone, surrounds the mouth. The movements involved in eating, drinking and whistling are all performed by the orbicularis muscle. In a constant state of contraction it gives a pursed and rather disapproving expression to the face.

The risorius is a thin, feeble muscle connected with the fascia of a muscle covering the hinder part of the lower jaw. The risorius is inserted into the corner of the mouth together with the depressor of this angle. It widens the mouth, drawing the corner backwards and downwards, giving the face a sad and somewhat cynical expression.

The buccinator muscle is situated between the upper and lower jaws on the sides of the face, and is attached to both these bony surfaces behind. To the front it blends with the orbicularis of the mouth. The buccinator compresses the wall of the cheek close to the gums as when blowing, hence the name of trumpeter's muscle by which it is known. It widens the mouth sideways and wrinkles the cheek, often producing a permanent crease on the surface of the face which curves downwards from about the middle of the cheek forwards to the lower jaw and chin.

The temporalis is a fan-shaped masticatory muscle on the side of the head bordering on the temporal ridge in front and filling the temporal hollow. The fibres of this muscle converge on a strong tendon which passes beneath the zygomatic arch to be inserted finally into the lower jaw. The temporalis is a powerful muscle; by elevating

the lower jaw it brings the lower teeth forcibly into contact with the upper.

The masseter is a short thick muscle. Originating from the lower border of the zygomatic arch on a broad tendon, it descends obliquely downwards and backwards and is inserted into the outer surface and angle of the lower jaw. The masseter has a powerful action in clenching the jaws.

SURFACE FORMS OF THE FACE

The muscles of the face are inserted into the soft tissues of the skin surrounding the mouth, and there is little or no evidence of their shape, size or direction upon the surface. They are further concealed by a certain amount of fat which is present, especially upon the cheeks and chin.

Broadly speaking the fat of the cheek, superficial over the depressed part of the maxillary bone, is situated upon the levator muscles of the upper lip and the buccinator muscle. This pad of fat masks the shape and obliquity of the muscles beneath. Even in emaciated faces when the falling in of the soft tissues gives a sunken appearance, the muscular shapes are obscured by a fold running almost at right angles to the direction of their fasciculi between the cheek and the corner of the mouth. This fold is concurrent with the groove on the upper surface of the maxillary bone above and behind the nostril. In a young face the convex form of the cheek blends smoothly into the plane of the upper lip. As age advances the skin loses its elasticity and the cheeks tend to sag and rest upon the outer surfaces of the maxillae bones underlying the upper lip.

A certain amount of fat is also present upon the eminence of the chin, and often there is a dimple or depression just above the chin corresponding with the attachment of the muscles beneath.

Where wrinkling takes place as on the forehead, at the outer corners of the eyes, upon the eyelids and over the bridge of the nose, it is due to the absence of fatty tissue and also because the skin is thinner in these parts. The direction of these wrinkles is at right angles to the pull of the muscles beneath.

The orbital sockets are set slightly back at an obtuse angle from the median line of the face so that the inner halves of the upper margins tend to project over the inner corners of the eyes, while the outer parts of the orbital margins recede, leaving convex forms between the outer parts of the brow and the outer corners of the eyes.

The set of the eyes within their orbital sockets varies in individual faces. In some faces the forms surrounding the eyes are full, while in others these surrounding parts are thin and then the upper lid extends far back upon the globe of the eye, showing the roundness of the protruding eyeball.

The growth of hair of the eyebrow usually commences from the lower surface of the superciliary ridge on the inner side and edge of the orbit. Growing upwards it

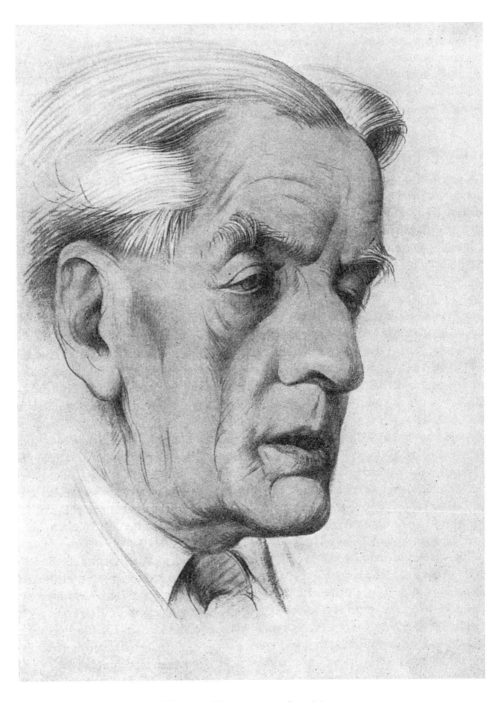

FIG. 23. HEAD OF AN OLD MAN

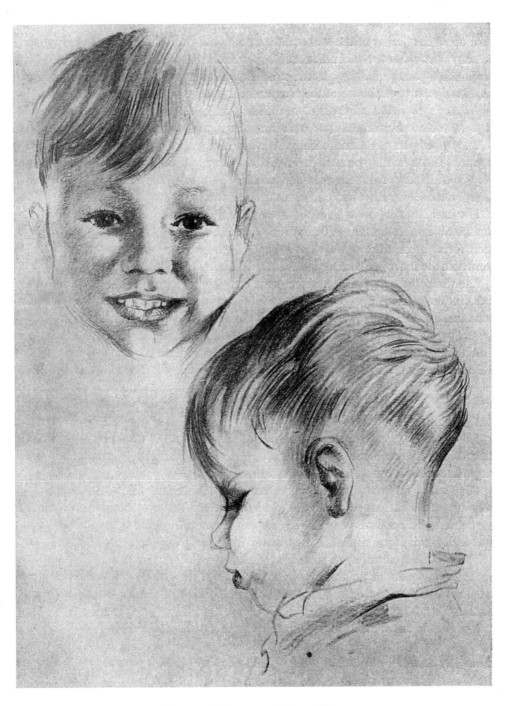

FIG. 24. HEAD OF A YOUNG BOY

49

surmounts the border of the socket. The hairs, lying closely together here, grow horizontally outwards for a short distance. Towards the outer side of the brow these hairs are joined by others and they descend obliquely outwards and downwards to terminate on the angular prominence of the temporal ridge.

With age the orbicular muscle surrounding the eye loses its elasticity and the skin sags upon the lower orbital border forming 'bags' under the eyes.

The upper part of the modelling of the nose depends on the nasal bones. The disposition of the cartilaginous part below the bridge and the tissues covering it varies very considerably with different individuals. The upper half of the nose however is always relatively narrow in comparison to the lower half.

The cheek bones, the zygomatic arches and the outer orbital margins are all distinguishable on the surface of the face and, in relation to the forehead and nasal bridge, these forms present the artist with the general symmetry of bony parts upon which to construct the more individual and mobile features of the face.

The thread of individual character runs through all the forms and features of the face, but those forms between the cheek bones and the mouth are often given too little attention by the student. The individual character of a person cannot be rendered merely by the drawing of the eyes, nose and mouth. One has only to realize that when smiling it is not only the corners of the mouth that are uplifted, but that the forms of the surfaces of the cheeks and lower eyelids are also altered. The soft and extremely mobile areas of the cheeks join with the eyes and mouth in the simultaneous expression of emotion and play of thought, and therefore play a very important part in giving the individual character to the face.

The mouth is a very expressive feature of the face, and it would be impossible to describe the infinite variety of its forms in different individuals. In some the lips are large, full and generous; in others they are small and pursed, and again in others the lips are rolled inwards. The mouth, whatever its individual shape, must always be drawn with the utmost regard to the eyes and cheeks. The eyes cannot smile without the corners of the mouth being raised, nor can the mouth appear sullen but the cheeks also relax their forms while the eyes betray a similarly sombre expression.

The chin does not of itself show much subtlety of character. It may be prominent or receding, square or pointed. Its importance from the artist's points of view lies in its relationship to the other facial forms, notably that of the lower jaw and cheek bones.

The auricle or ear is made up of a convoluted cartilage and several small muscles, and it is covered with a fine smooth skin. The position of the ear is determined by the meatus or auditory channel of the temporal bone to which it is attached. Somewhat oval in shape, broader above than below, it consists of two rims, the helix and the antihelix within. The ear may be large or small in relation to the head, and the soft lobule at its base may be round or pointed. From the side view the ear is placed more

or less centrally within the outline of the head; from the front it is about equidistant between the top of the cranium and the chin. Again, for the artist, the ear is important not so much as an expressive feature in itself but with regard to the position it occupies in the profile of the face. Though the profile may be perfectly described by the artist, if the ear is misplaced in relation to that outline it will entirely alter the character of the head.

Finally, the growth of hair upon the head adds considerably to the individual make-up of character, especially round the forehead and temples where it forms a frame to the face. Generally speaking the hair tends to spring from the vertex of the forehead and curve over the frontal eminences. It grows slightly below the curve of the temporal ridges, backwards and downwards, and then obliquely forwards again, terminating here upon the zygomatic arch. On the face the growth of hair extends along a line corresponding approximately to the horizontal ridges of the malar bones. It covers the cheeks and surrounds the mouth, leaving a very small area uncovered on either side of the lower surface of the lower lip.

3

THE UPPER LIMB

The Skeleton of the Shoulder Girdle

Broadly speaking the shoulder girdle takes its shape from the thorax underlying it and forms, diagrammatically, a parallelogram about the upper rib wall. The open angle between the two scapular bones is roughly equivalent to the surface width of the neck.

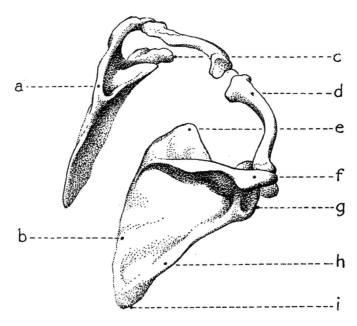

FIG. 25

a. Scapular spine
b. Vertebral border
c. Coracoid
d. Clavicle
e. Upper angle

f. Acromion
g. Glenoid cavity
h. Anterior border
i. Lower angle

52

THE SKELETON OF THE SHOULDER GIRDLE

The clavicle is approximately equal in length to the sternum, or breastbone, and is attached to the upper part of this bone. This attachment provides the only bony connection between the shoulder girdle and the skeleton of the trunk. The clavicle is superficial throughout and can be traced from the base of the neck to its articulation with the scapula, or shoulder bone.

The blade of the scapula is thin, flat and triangular. It is slightly convex in form, corresponding with the curve of the thorax; it is not, however, in direct contact with the rib wall, but separated a short distance from the skeleton of the trunk by muscular attachments. The blade of the scapula possesses three borders: the vertebral border turned towards the spinal column, the anterior border turned towards the armpit, and the upper or clavicular border horizontally behind the clavicle. It has also two angles: the upper angle at the vertebral end of the upper border, and the lower angle at the junction of the vertebral and anterior borders.

From the vertebral border of the scapula a shelf or spine slopes upwards, thickens and curves forwards. The outermost point of this spine is called the acromion. The anterior surface of the acromion is joined through ligamentary attachments to the outer end of the clavicle. The clavicle at this point is slightly raised above the acromion and gives the highest point of the shoulder, while the acromion provides the outermost limit to the shoulder and to the skeleton of the upper trunk.

THE SKELETON OF THE UPPER ARM

The upper arm is constructed on one bone called the humerus. The head of this bone is loosely attached to the scapula, resting against its socket rather than being received into it, thereby allowing great freedom of movement to the whole arm. At the elbow the cylindrical shaft of the humerus is expanded and forms an inner and outer condyle. Between these two condyles lies a pulley-like portion called the trochlea. To this surface the ulna of the forearm is fitted and, in articulation with the humerus, forms the hinge joint of the elbow.

The forearm is constructed on two closely related bones named the ulna and the radius. The ulna is the inner bone (the inside of the forearm is taken to be that surface on the side of the little finger). At the elbow where the ulna is enlarged, it articulates with the humerus; at its lower end it narrows and connects only indirectly with the wrist through attachments to the radius. The radius is large at the wrist and is joined to the wrist bones of the hand. At the elbow the radius is small. Its head is in contact with a rounded prominence on the humerus, the capitellum.

The skeleton of the hand is connected to the forearm through the lower end of the radius. The expanded end of the radius articulates with the first row of the carpal bones that form the main structure of the hand. These carpal bones articulate with each other and together form the carpus, a concavo-convex structure lying in the palm

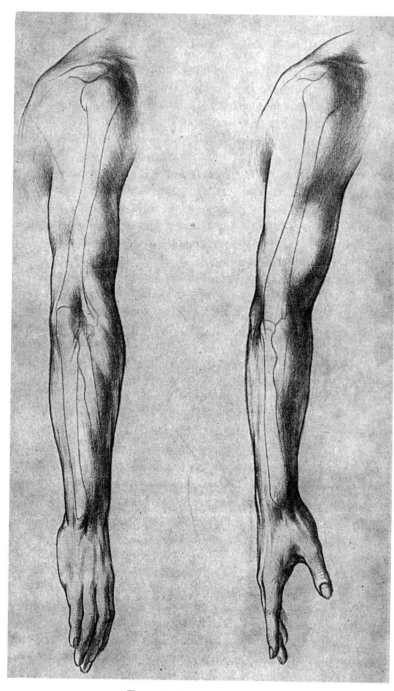

FIG. 26. THE RIGHT ARM
showing the position of the skeleton
left: from the side, with the forearm pronated
right: from the side, with the forearm supinated

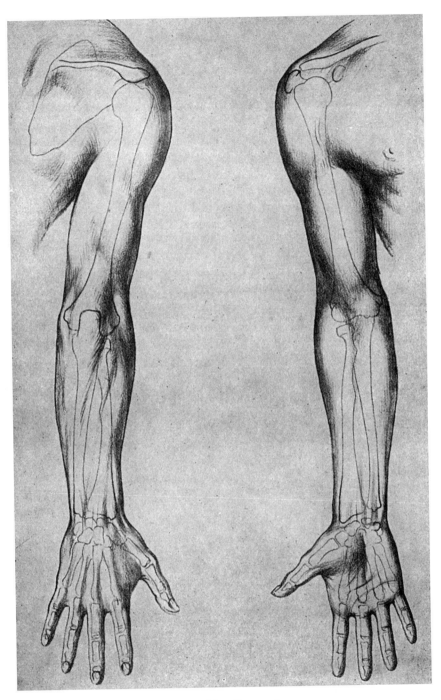

FIG. 27. THE RIGHT ARM
showing the position of the skeleton
left: from the back
right: from the front

55

of the hand. The five metacarpals which are joined to the carpal bones form the skeleton of the larger part of the palm. The metacarpal of the thumb is joined to a saddle-shaped bone called the trapezium; this gliding joint gives a very free movement to the thumb and allows the movements of opposition between the thumb and fingers. The fifth metacarpal is also relatively free, while the middle three are practically fixed.

THE DELTOID MUSCLE

The deltoid muscle of the shoulder is thick and triangular, and it is shaped rather like the inverted Greek letter delta. It arises from the lower edge of the scapular spine along nearly its whole length, from the outer border of the acromion, and from the outer third of the clavicle. From this extensive origin the muscular fibres converge to one strong pointed tendon which is inserted into the middle and outer side of the shaft of the humerus. The posterior part of the muscle is rather thin and flat; the middle part, descending vertically from the acromion, is fuller; the anterior part is again thick and made more prominent by the coracoid of the scapula and by the subjacent head of the humerus which is situated slightly in advance of the acromion point.

When the arm is raised from the side of the body the deltoid and the trapezius of that shoulder come visibly into action.

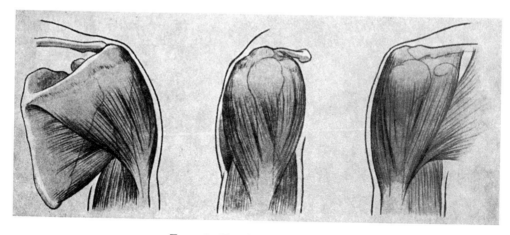

FIG. 28. THE DELTOID MUSCLE
showing the skeleton of the shoulder
a. From the back b. From the side c. From the front

THE SCAPULAR MUSCLES

The scapular group consists of five muscles which pass from the scapula to the humerus. They act generally as rotators of that bone. They are the subscapularis, the

supra and infra-spinati, and the two teres muscles. The muscles which most clearly influence the modelling on the surface of the scapula are the infra-spinatus and the teres major.

The upper and outer part of the scapular muscles is covered by the deltoid; the upper and inner part is covered by the trapezius, and the lower part is covered by the latissimus dorsi. From the triangular space enclosed by these muscles the infra-spinatus is often seen to bulge out in a full prominence on the blade of the scapula. At the lower angle of the bone the teres major, passing outwards to be inserted into the humerus, is overlaid by the latissimus dorsi, and combines with it to give an additional fullness to the contour behind the armpit.

Except when the arm is used as an additional means of support to the trunk, its movements are remarkably free and independent. We have seen how the lower limbs condition the posture of the trunk. The movements of the arms, on the other hand, have, generally speaking, little effect on the distribution of the weight of the body which must be evenly balanced throughout the trunk and lower limbs. This does not mean that the student should treat the arm as a separate entity. By studying the skeleton of the shoulder girdle it can be seen that the only bony attachment of the arm to the trunk is through the sterno-clavicular joint. Very nearly all the superficial muscles of the trunk, however, are bound up with the movements of the arm, either indirectly through the shoulder girdle or directly through their attachments to the humerus. Looking at the skeleton therefore, it is clear that the arm is almost completely free from the rest of the body, while, by studying the muscular arrangements of the shoulder, we see that the arm is closely bound up with the trunk and, by its movements, influences very considerably the surface modelling of the upper part of the front and back of the body.

SURFACE FORMS OF THE SHOULDER

In Fig. 29 the arm is resting by the side of the body and the muscles ranged over the shoulder are relaxed. The upper border of the spine of the scapula can be traced from the acromion to the vertebral border of the blade. The small triangular tendinous attachment of the trapezius, passing over the vertebral border of the scapula, causes an indentation at the root of the spine of that bone. This depression is accentuated by the deep fleshy mass of the rhomboids and by the levator scapulae muscles partially surrounding it. The trapezius, overlying these muscles, softens their elevation, and combines with them to give the beautifully modelled contour to this part of the figure.

In this position the ridge of the vertebral border of the scapula is distinct, but the lower angle of the bone is overlaid by the latissimus dorsi. This muscle, revealing the mass of the erector spinae through its thinner parts, can be traced outwards where it combines with the teres major to produce the fullness behind the armpit.

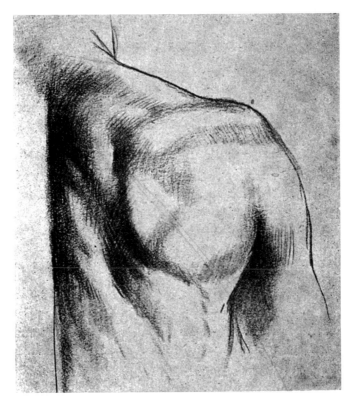

FIG. 29. THE RIGHT SHOULDER
with the arm resting by the side of the body

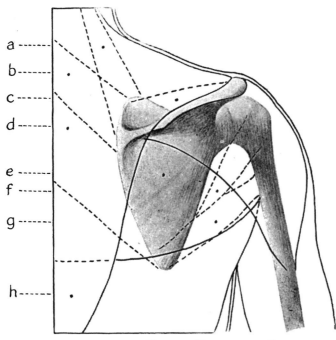

a. Levator scapula
b. Rhomboid minor
c. Supraspinatus
d. Rhomboid major
e. Infraspinatus
f. Teres minor
g. Teres major
h. Trapezius

FIG. 30. DIAGRAM OF FIG. 29

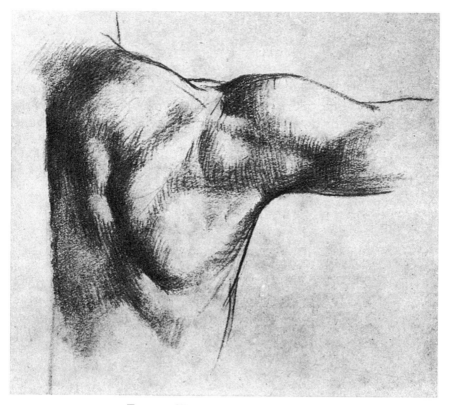

FIG. 31. THE RIGHT SHOULDER
with the arm raised to the level of the shoulder

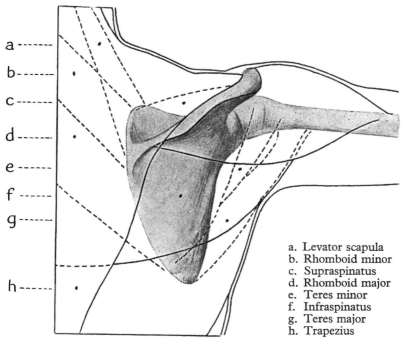

a. Levator scapula
b. Rhomboid minor
c. Supraspinatus
d. Rhomboid major
e. Teres minor
f. Infraspinatus
g. Teres major
h. Trapezius

FIG. 32. DIAGRAM OF FIG. 31

Fig. 31 shows the arm raised to the level of the shoulder by the action of the deltoid and also by the contraction of the trapezius. In this position the deltoid, by becoming contracted and hard, reveals the subdivisions of its fibrous masses. The lower angle of the scapula has swung outwards and the spine of that bone is therefore tilted more obliquely downwards towards the vertebral column. This action elongates the depression at the root of the spine, and a deep furrow along the vertebral border now

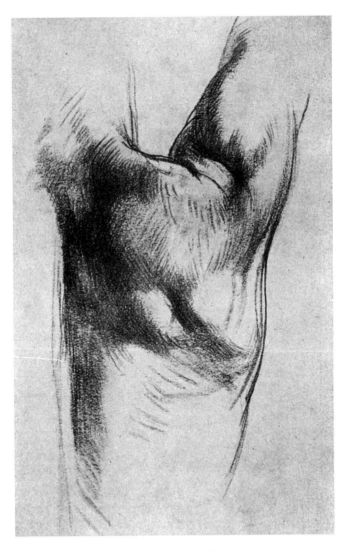

FIG. 33. THE RIGHT SHOULDER
with the arm raised above the level of the shoulder

indicates clearly the shifted position of the scapula. The muscular mass of the trapezius, being contracted, becomes more elevated.

Fig. 33. Here the arm is raised above the level of the shoulder. The contour of the trapezius has become more exaggerated than in the previous position. At the shoulder joint the surface of the acromion can be seen clearly separating the trapezius from the deltoid. The changes in surface modelling previously noted become more pronounced. The rotation of the scapula alters the position of the depression situated at the root of the spine, which depression is now much lower and farther from the spinal column. The lower angle of the scapula is pulled forwards and outwards, and is mainly responsible for the prominence on the side of the thoracic wall.

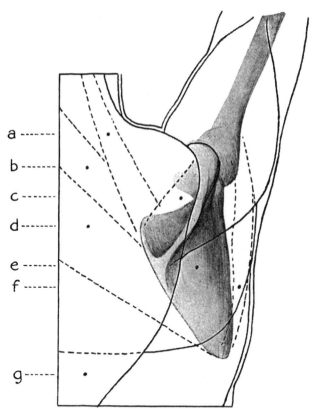

FIG. 34. DIAGRAM OF FIG. 33
a. Levator scapula
b. Rhomboid minor
c. Supraspinatus
d. Rhomboid major
e. Infraspinatus
f. Teres major
g. Trapezius

Another example of the action and surface modelling of the shoulder blades in rather a different position is illustrated in Fig. 9. The arms here are raised to the horizontal position; they are also brought forward to the front of the body. Compare this drawing with Fig. 31. The surface indication of the vertebral border of the scapula in Fig. 31 is represented by a pronounced ridge. The shoulder blade has been rotated by raising the arm, and the vertebral border now lies at a slant across the back. In Fig. 9 a similar rotation of the shoulder blades has taken place but, in addition, the bones have been drawn forwards round the thoracic wall, and their vertebral borders lie embedded beneath the powerful muscles surrounding them. In a normal position, with the arms relaxed at the sides of the body, the distance between the shoulder blades is approximately equal to the width of the neck. Comparing these two drawings, it can be seen to what extent the shoulder blades in Fig. 9 are drawn forwards by noting the increased distance which lies between them.

Fig. 13 demonstrates the same freedom and independence of the shoulder movement.

The Muscles of the Upper Arm

While the superficial muscles and aponeuroses on the trunk are broad and flat, the surface muscles of the limbs are usually long and rounded, and their tendons, which are thick, tapering and cord-like, are sometimes divided so as to reach several bones. This gives characteristics to the surfaces and contours of the limbs which contrast with those of the trunk. The shaft of the humerus is completely hidden by the muscular fullness, and the surfaces of this part of the arm are consequently supple and more malleable. At the elbow and wrist joints the muscles, becoming tendinous, allow the expanded ends of the bones to be easily distinguished on the surface. The shapes and sizes of these bony parts, and their constant mutual relationship during movements of the limb are of great help to the draughtsman in representing the joints with their characteristic firmness and relative strength, in contrast to the suppleness of the muscular forms disposed round the shafts.

The disposition of these muscular forms round the limbs is asymmetrical. The fullness of each muscle or group of muscles seldom if ever occurs at the same point round the shaft, but it is arranged in zigzag fashion round it giving, artistically, a rhythm of varying planes and contours. Generally speaking the muscles of the limbs, as elsewhere on the body, are grouped into such positions where they can combine their actions to a common purpose. Thus the muscle which extends the forearm lies at the back of the humerus, and the muscles which flex or bend it are grouped in front; the extensors of the fingers lie on the back of the forearm, while the flexors lie in front. (The front of the forearm is taken to be that surface which lies in front when the arm is by the side of the body with the palm of the hand facing forwards.)

THE FLEXOR GROUP

The flexor group of muscles consists of the biceps and the brachialis. The biceps is superficial except where it is covered by the pectoralis major and by the deltoid. It arises by two heads; the longer of these passes over the head of the humerus and is secured at its origin inside the shoulder joint; the shorter takes origin from the tip of the coracoid. Below the attachments of the deltoid and pectoral muscles, these two heads of the biceps muscle merge into the fleshy part where they form a full but

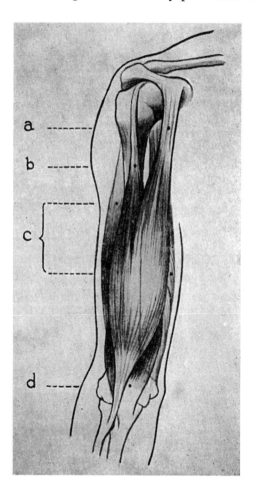

FIG. 35. THE FLEXOR MUSCLES OF THE RIGHT UPPER ARM
a. Biceps, short head
b. Biceps, long head
c. Triceps
d. Brachialis

slightly flattened mass. The muscle terminates on a strong tendon which, dipping into the hollow at the bend of the elbow, is inserted into the tuberosity of the radius. As it is about to disappear into the elbow bend the tendon gives off a fibrous band called the bicipital fascia, which spreads obliquely downwards and inwards over the fascia of the forearm below the elbow. The biceps flexes and supinates the forearm.

The brachialis originates from the lower half of the humerus below the attachment of the deltoid, and it is inserted into the upper end of the ulna. It is the more powerful of the two flexors of the elbow joint.

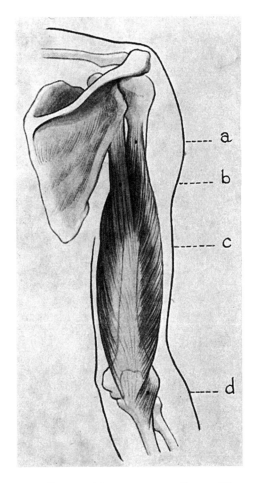

FIG. 36. THE TRICEPS MUSCLE OF THE RIGHT UPPER ARM
a. Triceps, outer head
b. Triceps, long head
c. Triceps, inner head
d. Anconeus

THE EXTENSOR GROUP

The extensor group is principally represented by the triceps muscle, although it also includes the anconeus.

The triceps arises by three heads. The long head originates from the scapula, the outer head from the upper end of the shaft of the humerus, and the inner head from the back of the humerus. The muscle is inserted by a broad common tendon which, commencing about the middle of the back of the arm, ends on the upper border and sides of the olecranon. The olecranon is the name given to the expanded upper end of the ulna. The triceps muscle is the extensor of the forearm. In vigorous actions like that of shovelling when the forearm is being alternatively extended and flexed, the movements of the triceps muscle can be seen clearly, its muscular masses contracting and relaxing, giving a rippling effect on the back of the upper arm.

The anconeus is a small superficial muscle, triangular in shape and rather flat. Narrow above, it spreads out over the outer side and back of the elbow joint. Its action helps to extend the forearm.

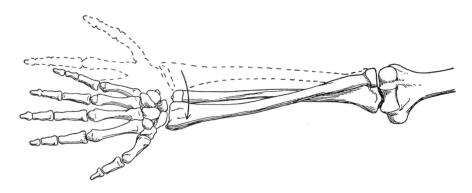

FIG. 37. THE RIGHT FOREARM
showing the movement of pronation

SURFACE FORMS OF THE UPPER ARM

The brachialis combines with the biceps to give the fullness to the front of the upper arm. The triceps occupies the whole of the back of the upper arm, displaying a fullness where it emerges from the deltoid and teres major and minor, which muscles conceal its origins. The tendinous part of the triceps gives a flattish surface to the lower part of the upper arm. The anconeus appears on the surface to be a continuation of the outer and lower part of this muscle, extending beyond the joint of the elbow.

65

THE MOVEMENTS OF PRONATION AND SUPINATION

When the elbow is flexed so that the palm of the hand faces upwards with the thumb on the outer side, the hand is in the supinated position. If, with the elbow still flexed, the hand is turned from the supine position so that it faces downwards with the thumb

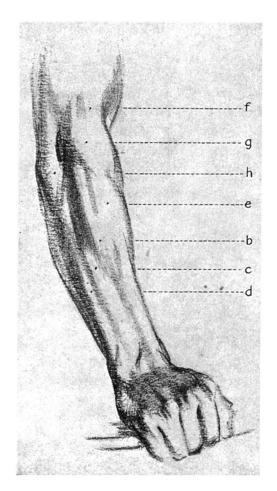

FIG. 38. THE RIGHT ARM PRONATED
See key to Fig. 39

on the inner side, it assumes the pronated position. In the position of supination the ulnar and radial shafts lie side by side. To pronate the forearm the radius, the head of which remains on the outer side of the ulna, is rotated round its own axis, carrying the hand with it.

THE MOVEMENTS OF PRONATION AND SUPINATION

When the elbow is extended, rotation of the humerus is added to the movements of pronation and supination, and the hand can then be carried round through an almost complete circle.

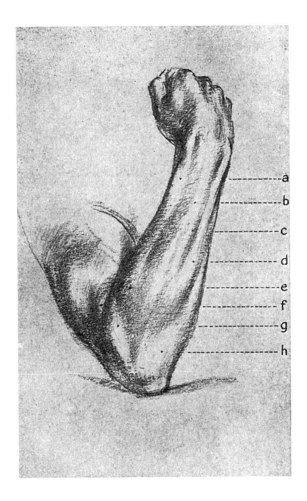

FIG. 39. THE RIGHT FOREARM SUPINATED AND FLEXED
- a. Extensors of thumb
- b. Common extensor of fingers
- c. Extensor of little finger
- d. Ulnar extensor of wrist
- e. Short radial extensor of wrist
- f. Brachio-radialis
- g. Long radial extensor of wrist
- h. Anconeus

Pronator and Flexor Muscles of the Forearm

This group of muscles includes two pronators, three flexors of the wrist, and three long flexors of the fingers and thumb.

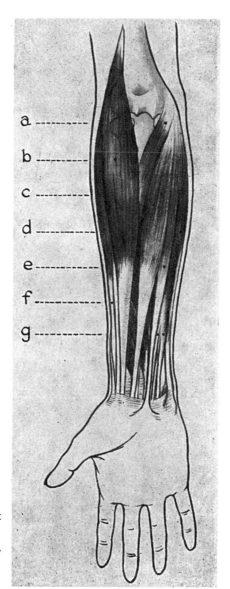

a. Pronator Teres
b. Brachio-radialis
c. Radial flexor of wrist
d. Ulnar flexor of wrist
e. Palmaris longus
f. Short radial extensor
 of wrist
g. Flexors of fingers

FIG. 40. PRONATOR AND FLEXOR MUSCLES OF THE RIGHT FOREARM

PRONATOR AND FLEXOR MUSCLES OF THE FOREARM

The pronator teres arises from the inner condyle of the humerus. Sloping downwards and forwards, this spindle-shaped muscle forms the inner border of the hollow at the bend of the elbow. It is inserted by a short tendon into the outer side of the radius. The pronator quadratus, attached to the lower ends of the ulnar and radial shafts, lies deep.

The radial flexor of the wrist originates from the inner condyle of the humerus. Lying next below the pronator teres, the fleshy portion of the radial flexor is rounded and full along the inner border of the forearm. Becoming tendinous about the middle of the forearm, the radial flexor ends on a long tendon which enters the palm of the hand, to be inserted into the bases of the second and third metacarpals.

The palmaris longus is a small, slender and superficial muscle. It arises from the inner condyle of the humerus, and ends on a long, thin tendon which is inserted into the fascia of the palm. The tendons of the palmaris longus and radial flexor of the wrist are both prominent on the front of the forearm when the hand is flexed.

The ulnar flexor of the wrist is the innermost of the superficial group of muscles. Originating from the inner condyle of the humerus, the fleshy part of this muscle is long and thick, and adds considerably to the curved contour of the inner side of the forearm. It becomes tendinous about the lower half of the forearm, and is inserted into the pisiform of the carpus.

The superficial and deep flexors of the fingers and the flexor of the thumb extend to the end of the phalanges. These muscles increase the bulk of the forearm, though they are themselves almost entirely concealed.

SUPINATOR AND EXTENSOR MUSCLES OF THE FOREARM

This group of muscles includes two supinators, three extensors of the wrist, three extensors of the fingers and three extensors of the thumb.

The two supinators are the brachio-radialis and the supinator brevis. The brachio-radialis is superficial. Arising from the lower ridge and outer condyle of the humerus, this long muscle forms the outer boundary of the hollow of the elbow. It also gives additional fullness to the fleshy form of the outer border of the upper part of the forearm. Twisted above, the fleshy fibres of this muscle end about the middle of the forearm on a tendon which is inserted into the lower end of the radius. The action of the brachio-radialis in supinating the forearm is slight. It is a strong flexor of the elbow. The supinator brevis is deep-seated beneath the brachio-radialis. This muscle is the direct and more powerful supinator of the wrist and hand.

The long radial extensor of the wrist is superficial except above, where it is overlapped by the brachio-radialis, and below, where it is crossed by the extensors of the thumb. The long radial extensor originates from the lower ridge of the humerus. Making a similar twist to that of the brachio-radialis, this muscle descends on a long

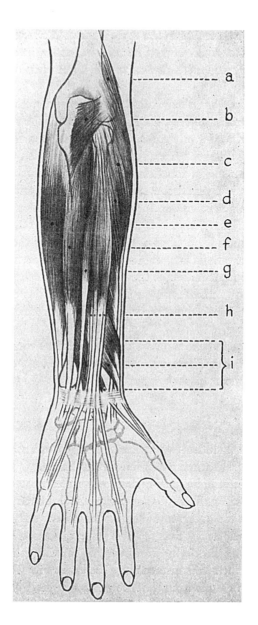

FIG. 41. SUPINATOR AND EXTENSOR MUSCLES OF THE RIGHT FOREARM

a. Brachio-radialis
b. Anconeus
c. Long radial extensor of wrist
d. Short radial extensor of wrist
e. Ulnar flexor of wrist
f. Ulnar extensor of wrist
g. Extensor of little finger
h. Common extensor of fingers
i. Extensor of thumb

tendon which is inserted into the base of the metacarpal of the index finger. It extends the wrist and bends the hand backwards.

The short radial extensor is a thick muscle, originating with the long extensor from the ridge of the humerus above the outer condyle. This muscle is covered above by the long radial extensor, but it appears below, where together these two extensors form the outer border of the forearm. Crossed below by the extensors of the thumb, the tendon of the short extensor disappears, to be inserted into the base of the meta-carpal of the middle finger. Its action is similar to that of the long extensor.

The ulnar extensor of the wrist lies on the back of the forearm, and forms the posterior boundary of the ulnar furrow. This furrow can be seen when the forearm is supinated. The ulnar extensor arises from the outer condyle of the humerus, and is inserted into the base of the fifth metacarpal bone.

The extensors of the fingers are situated between the ulnar extensor and the short radial extensor of the wrist. The common extensor of the fingers is superficial throughout. Arising from the outer condyle of the humerus, and forming one mass above, its fibres end about the lower third of the forearm on a flat tendon. This tendon divides into four slips which diverge over the back of the hand and extend to the phalanges of the fingers. The extensor of the little finger is a small superficial muscle lying between the common extensor and the ulnar extensor of the wrist. This small muscle arises with the common extensor from the outer condyle of the humerus. It descends to the phalanges of the little finger, allowing that finger an independent movement of extension. A third extensor attached to the forefinger lies beneath the common extensors.

The three extensors of the thumb emerge between the common extensor of the fingers and the short radial extensor, in the lower half and outer side of the forearm. These muscles, as a group, form the contour of the outer border of the lower forearm. The tendons of these muscles become apparent as they pass over the end of the radius towards the root of the thumb; they are clearly seen when the thumb is extended outwards from the hand.

Surface Forms of the Elbow and Forearm

The head of the ulna, the olecranon, can be distinguished clearly from behind throughout all movements and in all positions of the elbow joint. The outer condyle of the humerus is, as a general rule, hidden between the combined mass of the supinator and extensor muscles and the olecranon. The inner condyle, being only thinly covered by muscles, is prominent and provides the contour of the joint on the inner side.

The surface forms of the forearm vary very considerably according to whether the forearm is supinated or pronated. When the arm is relaxed by the side of the body it rests, roughly speaking, in a position midway between pronation and supination.

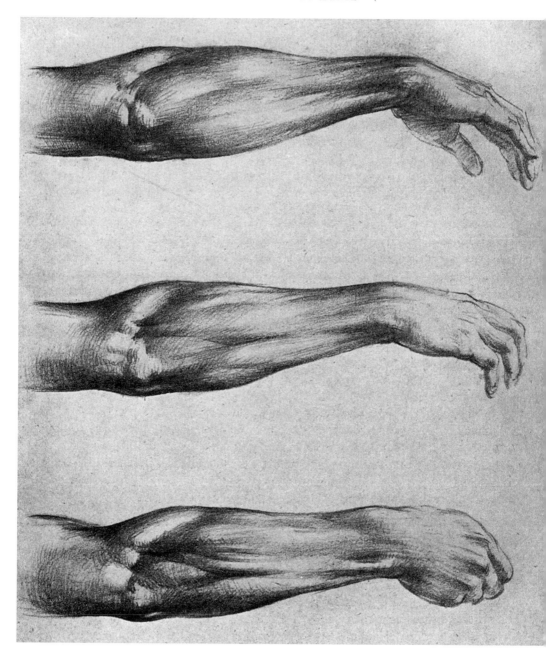

FIG. 42. SURFACE FORMS OF THE RIGHT ELBOW AND FOREARM
showing the forearm pronated, midway between
the pronation and supination, and supinated

In this position the two main masses of the supinator-extensor group and the pronator-flexor group are separated on the back of the forearm by a line taken from the head of the radius to the lower end of the ulnar shaft, and on the front by a line taken from the hollow of the elbow to the lower end of the radius. The modelling in this position shows the furrow concurrent with the upper half of the ulnar shaft.

When the hand is pronated the subdivisions between the extensors of the fingers is less distinct and they appear more as one mass. The ulnar furrow is less

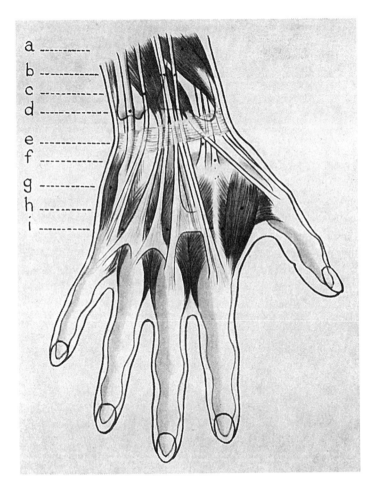

FIG. 43. THE DORSAL MUSCLES OF THE RIGHT HAND

a. Extensor of thumb
b. Common extensors of fingers
c. Extensor of little finger
d. Ulnar extensor of wrist
e. Short radial extensor of wrist
f. Long radial extensor of wrist
g. Abductor of little finger
h. First dorsal interosseous
i. Dorsal interossei

73

accentuated by the muscles bordering it, and the surface on the inner side of the fore-
arm shows a more continuous contour from the ulnar flexor across the ulnar shaft to
the ulnar extensor. When the hand is extended backwards all the muscular forms on
the back of the forearm become more clearly distinguished from each other.

The form of the front of the forearm, being composed mainly of the fleshy parts of
the brachio-radialis and the radial flexor, does not exhibit much variation of inter-
muscular markings. In the supinated position the pronator-flexor group of muscles

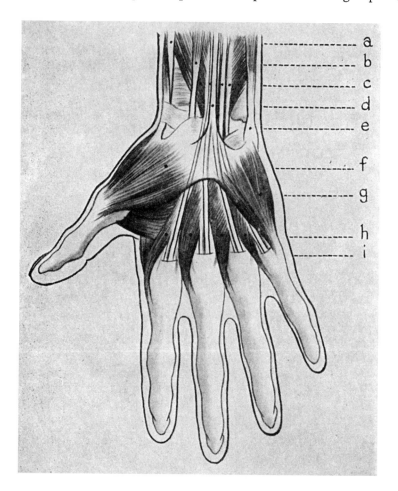

FIG. 44. THE PALMAR MUSCLES OF THE RIGHT HAND

a. Extensor of thumb f. Abductor of thumb
b. Radial flexor of wrist g. Abductor of little finger
c. Flexors of fingers h. Lumbricales
d. Palmaris longus i. First dorsal interosseous
e. Ulnar flexor of wrist

74

lie in an oblique direction downwards and outwards towards the thumb. When the hand is pronated the muscular and tendinous forms on both the front and back of the forearm lie in a longitudinal direction.

In Fig. 38 the forearm is pronated. The wrist is bent back on the arm, and the fingers are clenched. These actions bring all the superficial muscles of the forearm into play. In Fig. 39 the forearm is supinated; it is also flexed upon the arm by the actions of the biceps and brachialis. These muscles, becoming contracted, form a prominent bulge above the elbow joint.

THE MUSCLES OF THE HAND

The muscles that lie in the palm of the hand are grouped into two main masses. The one at the base of the thumb is called the thenar eminence; the other, at the base of the little finger, is called the hypothenar eminence. The thenar group consists of two abductors, one short flexor and an opponens muscle. The hypothenar group includes an abductor, an opponens and a short flexor muscle. The four interosseous muscles lie deep in the palm, but they are superficial on the back of the hand, occupying the spaces between the metacarpal bones.

SURFACE FORMS OF THE HAND

The tendons of the forearm, extending into the hand, are held close to the wrist joint by the anterior and posterior annular ligaments. These two bands are continuous above with the fascia of the forearm, and below with the palmar and dorsal fasciae. In front of the wrist only the scaphoid and the pisiform bones of the carpus are prominent on the surface. The pisiform, situated at the root of the little finger, remains, in all positions of the hand, an easily recognizable landmark from which to determine the more changeable forms surrounding it.

The back of the hand, though covered by numerous extensor tendons, retains the general convex form of the carpus. The dorsal surface of the fifth metacarpal is almost entirely superficial on a thin hand, while the other metacarpal bones are scarcely visible beneath the tendons.

The central, depressed part of the palm of the hand between the thenar and hypothenar groups of muscles corresponds with the fan-shaped part of the palmar fascia. This is a thick membranous covering, blending with the anterior annular ligament and with the tendon of the palmaris longus. This fascia obscures the bony, muscular and tendinous forms lying in the palm.

The first row of knuckles is provided by the heads of the metacarpal bones, and these prominences are therefore more or less rounded. The second and third rows of knuckles, corresponding with the ends of the first and second phalanges, have flatter

FIG. 45. THE SURFACE FORMS OF THE BACK OF THE RIGHT HAND
showing the position of the skeleton

FIG. 46. THE SURFACE FORMS OF THE PALM OF THE RIGHT HAND
showing the position of the skeleton

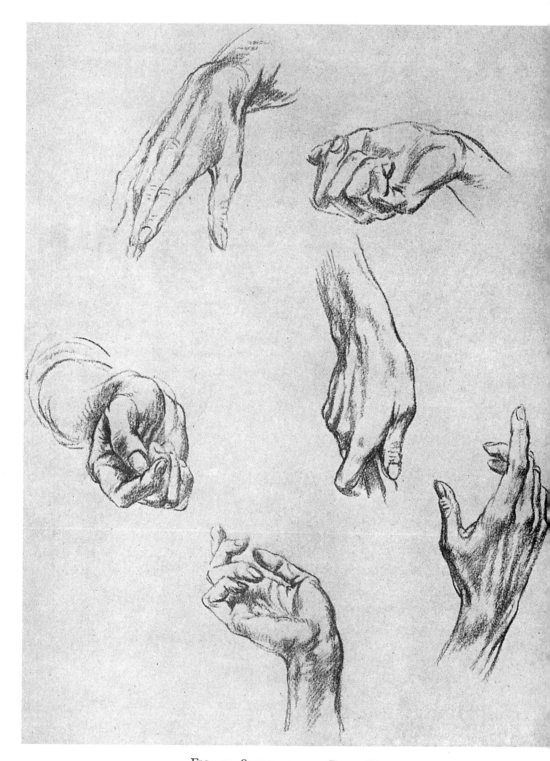

FIG. 47. STUDIES OF THE RIGHT HAND

squarer contours. The digital phalanges govern the general form of the fingers, the influence of these bones is especially apparent on the back of the fingers over the dorsum of each phalanx.

The three extensors of the thumb can be traced clearly if the thumb is extended and held out from the hand. If the thumb is moved backwards and forwards while still being extended outwards, the tendons of these muscles can be seen to bridge the space between the lower end of the radius and the base of the thumb.

The first interosseous muscle, ending at the base of the index finger, produces a prominent contour behind the web of skin connecting that finger with the thumb. This muscle occupies the area between the first and second metacarpal bones.

Pronation and supination of the hand are mainly dependent on the movements of the forearm. When rotation of the humerus is added to pronation and supination, the hand possesses an astonishing range of movement and manipulation.

The hand, perhaps more than any other single feature of the human body, is moulded by the brain that uses it. I am inclined to think that of all features it is the most characteristic of its owner. We can, and often do, take pains to conceal the true expression of ourselves in our faces, as we also hide behind words that do not tell of ourselves as we truly are; but no one can disguise the shape of his or her hands, nor can we hold them, gesticulate with them, nor use them in any other ways but those that will denote us truly. The human hand is so constantly in use. It has developed down the centuries of mankind into a wonderful form, not always beautiful, but always remarkable. It has been said that man is a tool-making creature. The hand of man is itself a most remarkable tool. With its freedom and wide range of movements it can execute wonders, scientific and artistic.

4

THE LOWER LIMB

THE SKELETON OF THE LOWER LIMB

The femur lies obliquely within the thigh, slanting downwards and inwards, and is at the same time bowed forwards. The head of the femur is fitted deeply into the acetabulum of the pelvic bone and forms with this surface the largest ball-and-socket joint in the body. This head of the thigh bone is joined to the main shaft by a short neck of bone, which runs outwards and slightly downwards to form an obtuse angle with the major part of the femur. The vertex of this angle is enlarged on the outer side to form the great trochanter. The prominence of the great trochanter, although concealed by the surrounding muscles and tendinous attachments, influences very considerably the surface form of the upper part of the thigh. The two great trochanters on the outer sides of the thighs provide the limit of width to the skeleton of the lower limbs.

The lower end of the femur is expanded to form two condyles; the inner of these two rounded forms is somewhat larger and longer than the outer. The femoral shaft runs obliquely inwards towards the knee, but the greater size of the inner condyle in comparison with the outer brings the lower surfaces of the femur to rest horizontally on the tibia.

The tibia, the largest of the two bones that form the skeleton of the leg, is a little shorter than the femur of the thigh. The tibia is expanded at both ends to form, above, the inner and outer tuberosities and the bony projection to the front called the tubercle; below, it forms the sharp projection above the inner part of the ankle joint. These features of the tibia, together with the long inner surface of its shaft, can be clearly detected on the model.

The fibula is a slender bone lying on the outer side of the leg, parallel to and slightly behind the tibia. The lower end of this bone is expanded to form the outer prominence above the ankle joint. The fibula and the tibia are secured to each other by strong ligaments, and together give a rounded form to the leg. As they are of approximately

80

equal length, and as the head of the fibula is situated below and behind the outer tuberosity of the tibia, the outer bone visible at the ankle is seen to be below and rather behind that on the inner side.

The patella is a small triangular bone situated in front of the knee. It is made secure there by tendons above, and by a strong ligament below. Situated above the joint line of the knee, with its base upwards and its apex downwards, this bone provides the cap of the knee and is apparent to some extent in all positions of the leg.

The foot is constructed in a similar fashion to the hand, but with this difference, that the hand is an exceedingly mobile feature while the foot acts mainly as a support for the body. It is described later on in connection with the numerous tendons attached to its surface.

The bones of the lower limb and the muscles surrounding them alternate in presenting the contour of the forms. At the joints, where the bones are expanded, the muscles taper and flatten into tendons, thus displaying a changeover from the fleshiness of muscle to the firm rigidity of bone. The surface effect surrounding the shaft is of a certain massiveness of form, the contours of which alter according to whether the muscles are contracted or in a state of relaxation. At the joints, on the other hand, the bony forms can be depended on to remain in constant relationships to each other. For instance, between the hip joint and the knee the muscles are exceedingly fleshy and bulky, and altogether hide the shaft of the femur. At the knee the expanded ends of the femur come very near to the surface while the muscles, becoming tendinous, show clearly the forms of the condyles over which they pass. When the knee is flexed the lower end of the femur rolls backwards on the upper surface of the tibia; the femur and the tibia are now more widely separated in front of the joint, but the central projecting parts of the condyles of the femur remain approximately in the same relationship to the tuberosities of the tibia whether the knee is extended or flexed.

The muscles of the lower limb, as also in the arm, are grouped together where they have a common purpose of movement; thus the extensors lie to the front of the thigh and the flexors behind, while the adductors and the abductors lie on the inner and outer sides of the limb respectively.

When the human body is considered anatomically the matter of weight and its support is very important, for this is what conditions the posture of the trunk and lower limbs. Balance is achieved through the even distribution of weight throughout the body. The lower limbs are developed to bear the weight of the body. In an upright position the weight of the upper part of the body is supported on the sacral part of the pelvic girdle; from here the thrust is transmitted outwards to the femoral shafts, thence to the thighs, legs, and to the feet. The pelvic girdle forms, so to speak, a pedestal for the trunk; the lower limbs support that pedestal. The student should realize the importance of treating the trunk and lower limbs together as one entity of support, and not as two separate structures.

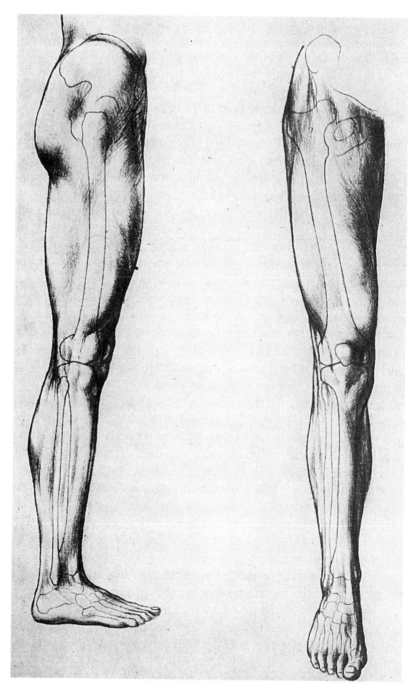

FIG. 48. THE RIGHT LEG
showing the position of the skeleton
left: from the outer side
right: from the front

82

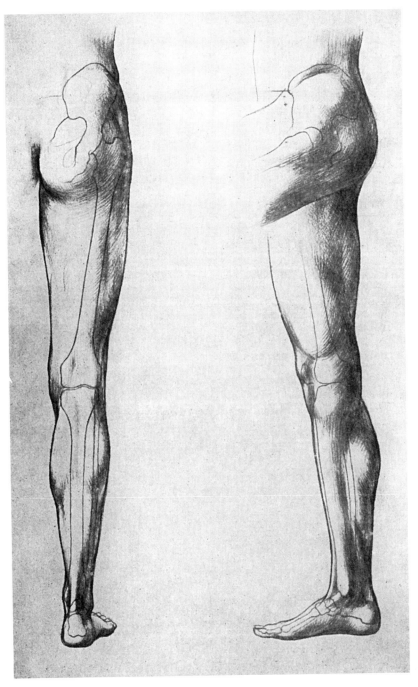

FIG. 49. THE RIGHT LEG
showing the position of the skeleton
left: from the back
right: from the inner side

83

THE LOWER LIMB

There is little surface indication of the skeleton of the pelvic girdle. The main parts of the pelvic bones are obscured by the gluteal muscles which are ranged over the sides and back of the hips; moreover the shape of these muscles is concealed by a quantity of fat. The only bony parts of the pelvic girdle that may be apparent are the iliac crests, and the junctions of the pelvic bones to the sacrum. A comparison of the form of the gluteus maximus in Figs. 52, 53, with the surface forms indicated in these drawings shows how the presence of fat gives a full rounded shape corresponding little with the obliquely disposed muscles beneath.

THE MUSCLES OF THE THIGH

THE ABDUCTOR MUSCLES

The superficial muscles of the hip consist of the gluteus maximus, the gluteus medius and the tensor fasciae femoris. These muscles all abduct the thigh, carrying it away from the body. All three muscles originate from the upper part and crest of the pelvic bone. Their muscular fibres converge on the prominence of the great trochanter where they flatten and join with the fascia of the thigh which is called the ilio-tibial band.

The foremost of these muscles is the tensor fasciae femoris, a short, flat, but thick muscle originating from the front of the iliac crest. The gluteus maximus originates from the posterior crest of the pelvic bone, from the sacrum and from the coccyx. The gluteus medius, situated between these two muscles, originates from the middle surface of the hip bone, and is more than half concealed by these other two muscles which overlap its borders to meet at an angle over the great trochanter. The gluteus medius forms the outline of the hip from in front and from behind.

SURFACE FORMS OF THE HIP

On the model a shallow depression can often be seen running from the summit of the iliac crest forwards and downwards to a position a little above the great trochanter. This depression will correspond to the division between the two gluteal muscles. There is little or no indication of any muscular subdivision between the gluteus medius and the tensor fasciae femoris; these two muscles appear to blend, and give a rounded contour to the upper and front part of the hip. The hollow above and behind the great trochanter is checked in front by the tensor fasciae femoris muscle. The muscular mass of the tensor fasciae femoris, descending lower than the corresponding parts of the gluteal muscles, fills out that part in front of the trochanter major. It will be seen that the fleshy parts of the muscles of the outer thigh are ranged mainly above the hip joint. Round the upper end of the femoral shaft the muscles flatten and merge into the fascia of the thigh and the ilio-tibial band, and descend vertically on a broad tendon to the outer side of the knee.

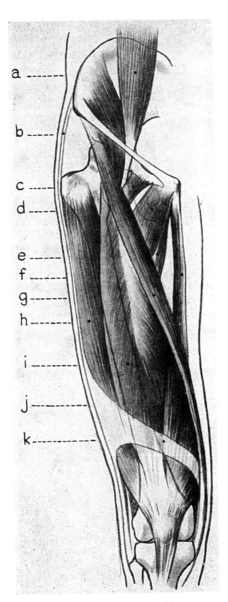

THE MUSCLES OF THE THIGH
FIG. 50. From the front

a. Psoas magnus
b. Ilio-tibial band
c. Pectineus
d. Adductor brevis
e. Semi-membranosus
f. Gracilis

g. Sartorius
h. Vastus externus
i. Rectus femoris
j. Vastus internus
k. Band of Richer

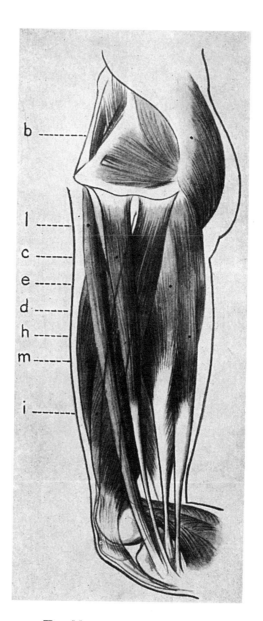

THE MUSCLES OF THE THIGH
FIG. 51. From the inner side

b. Gluteus maximus
c. Gracilis
d. Adductor magnus
e. Semi-membranosus

h. Semi-tendinosus
i. Vastus internus
l. Sartorius
m. Rectus femoris

THE FLEXOR MUSCLES

This group consists of the biceps femoris, the semi-tendinosus and the semi-membranosus. The biceps femoris originates from the ischial tuberosity and also from the back of the femoral shaft; these two heads join about the lower thigh and the muscle is inserted into the head of the fibula. The semi-tendinosus also originates from the ischial tuberosity. It descends vertically upon the semi-membranosus, and with a very long tendon is inserted with a graceful curve forwards into the inner surface of the tibia. The semi-membranosus is overlaid by the semi-tendinosus and by the biceps, and with them descends vertically to the knee where it is inserted into the inner tuberosity of the tibia.

SURFACE FORMS OF THE FLEXOR GROUP

The three flexor muscles together present a fullness about the middle of the femoral shaft, a fullness which narrows gradually as the muscles descend. Above the back of the knee, where the muscular mass flattens and divides, the tendon of the biceps femoris passes outwards to the head of the fibula, while the others curve inwards round the tuberosity of the tibia. On the other side of the thigh, between the biceps and the vastus externus of the extensor group, there is often a fairly distinct intermuscular marking or linear depression which runs vertically down the thigh to the knee.

THE ADDUCTOR-FLEXOR AND THE ADDUCTOR MUSCLES

There are two adductor-flexor muscles: the sartorius and the gracilis. Both of these long, slender muscles are superficial throughout. They adduct the thigh, that is, draw it inwards towards the other thigh; they also combine with the flexors to bend the leg at the knee joint.

The sartorius is a flat ribbon-shaped muscle which originates from the anterior superior spine of the pelvic bone. Sweeping obliquely downwards and inwards over the thigh, it curves forwards at the knee to be inserted into the inner side of the tibia. The gracilis arises from the pubic bone. Descending on the innermost side of the thigh, it is inserted into the tibia behind the tendon of the sartorius.

The adductor group of muscles lies on the upper and inner side of the thigh, and is to a large extent covered by the sartorius and by the gracilis. There are four muscles belonging to this group; they are the pectineus, the adductor brevis, adductor longus and adductor magnus.

The pectineus, the uppermost of this group, is a short, flat muscle crossed below by the sartorius. The adductor brevis, lying next to it, is covered not only by the pectineus above, but by the adductor longus below and by the sartorius. The adductor longus is discernible above; below, it is covered by the sartorius and by the gracilis.

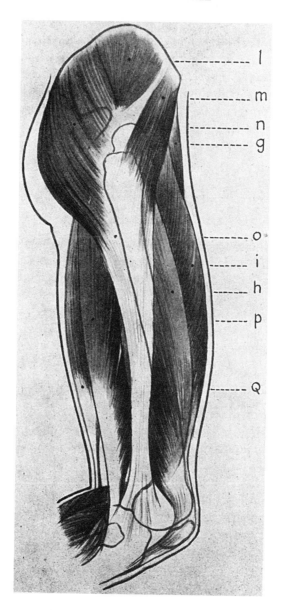

THE MUSCLES OF THE THIGH
FIG. 52. From the outer side

g. Sartorius
h. Vastus externus
i. Rectus femoris
l. Gluteus medius
m. Tensor fasciae femoris

n. Gluteus maximus
o. Ilio-tibial band
p. Biceps femoris
q. Semi-tendinosus

THE ADDUCTOR-FLEXOR AND THE ADDUCTOR MUSCLES

The adductor magnus is the largest and the innermost muscle of this group, and is almost entirely concealed by the gracilis.

SURFACE FORMS OF THE ADDUCTOR-FLEXOR AND ADDUCTOR GROUPS

The sartorius, lying in the oblique groove between the adductors and the extensors, clearly divides these groups into two separate masses. The adductors occupy the area between the femoral shaft and the inner border of the thigh. The gracilis, obscuring the deeper muscles, smooths the modelling of the inner surface of the thigh, so that there is little or no surface indication of sub-division between the individual muscles.

THE EXTENSOR MUSCLES

The general direction of the extensor group of muscles, which lie in front of the thigh, follows that of the femoral shaft. This group consists of four muscles: the vastus externus, the vastus internus and the rectus femoris, superficially with the crureus hidden beneath them. Together they constitute the quadriceps extensor cruris.

The vastus externus, the outermost of these muscles, is covered by the ilio-tibial band which conceals its origin from the neck and great trochanter of the femur. It becomes broad and thick about the middle of the femoral shaft, keeping to the direction of that bone. Flattening about the outer condyle, the vastus externus joins with the common tendon of insertion which it shares with the vastus internus and with the rectus femoris.

The vastus internus originates from the whole length of the femoral shaft, from its front and inner sides. It is covered above by the rectus femoris. Lower on the thigh it appears broad and full between the rectus muscle and the sartorius. Its fleshy part descends lower than that of the vastus externus, and its tendinous fibres are almost horizontal as they join with the common tendon of insertion to the patella.

The rectus femoris is a very long muscle. It originates from the anterior superior spine of the pelvic bone, and is inserted into the upper border of the patella and finally, by a ligament, into the tubercle of the tibia. Tapered at its origin, the rectus femoris broadens as it emerges between the sartorius and the tensor fasciae femoris. It passes obliquely downwards, parallel with the axis of the thigh. It is also curved forwards by the slight convexity of the femur.

SURFACE FORMS OF THE EXTENSOR GROUP

Except above, at its origin, the boundaries of the rectus femoris are clearly perceptible, especially when this muscle is in action. The common tendon and method of insertion of the extensors is best seen when they are in action, for then the lower parts of the

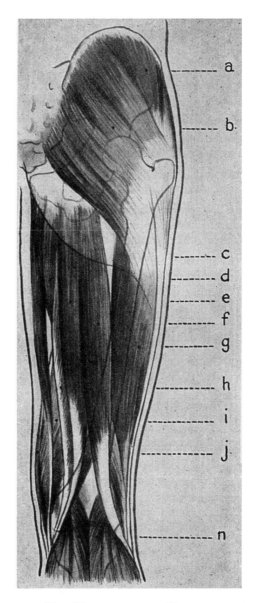

THE MUSCLES OF THE THIGH
FIG. 53. From the back

a. Gluteus medius
b. Gluteus maximus
c. Gracilis
d. Adductor magnus
e. Semi-tendinosus
f. Biceps femoris

g. Vastus externus
h. Semi-membranosus
i. Vastus internus
j. Sartorius
n. Gastrocnemius

quadriceps harden and the abrupt flattening of their forms as they end on the common tendon is thus shown.

When the extensors are in action the flexor muscles relax; when the flexors come into play it is necessary for the extensors to relax. An understanding of this interplay of muscular movement is very helpful to the artist. By selecting and emphasizing the muscles in action at the expense of those that are relaxed, he can give a more forceful expression to his drawing.

SURFACE FORMS OF THE KNEE

All the muscles descending the thigh extend over the joint of the knee to insertions

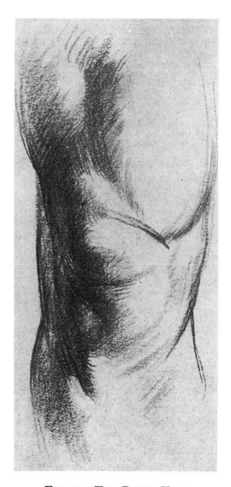

FIG. 54. THE RIGHT KNEE
with the extensor muscles contracted

91

into the tibia and fibula. From the back the flexors can be seen to flatten and separate, enclosing the popliteal space behind the knee. Both the outer and inner surfaces of the joint are wrapped round by tendons of the thigh. In front the extensors gather to the common tendon which, passing over the joint, is inserted into the tubercle of the tibia. The gastrocnemius or calf muscle is the only muscle of the leg which takes origin

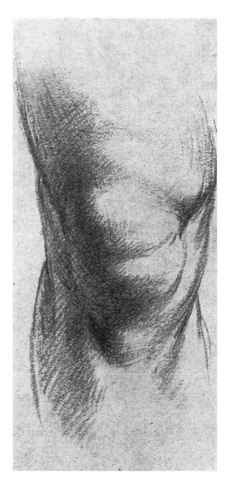

FIG. 55. THE RIGHT KNEE
with the extensor muscles relaxed

above the knee joint. This muscle arises from the condyles of the femur and emerges from between the tendons of the thigh as they divide above the knee joint.

Fat is present on either side of the ligament which passes over the patella to the tubercle of the tibia. These pads of fat are only evident when the knee is extended.

At the back of the knee joint is more fat which also is only evident when the knee is extended. When the knee is flexed the pads of fat bordering the patella are withdrawn inwards leaving the ligament to stand out in front of the joint. At the back, when the knee is flexed, the pad of fat, superficial on the gastrocnemius muscle, emerges from between the flexor tendons of the thigh.

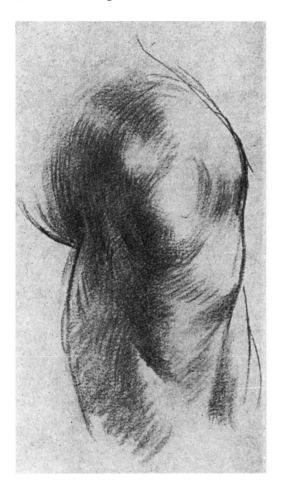

FIG. 56. THE RIGHT KNEE, FLEXED

When the extensors of the thigh are in action they contract and harden, and this makes noticeable changes to the surface forms above and around the knee. The action of these extensor muscles pulls the patella upwards and slightly outwards, and draws it closer to the condyles of the femur. See Fig. 54. The folds of fat on either side of the ligament are not now so evident. Above the knee the contraction of the muscles shows

93

up their lower fleshy borders, and exposes a flattish surface corresponding in position to the tendon of the rectus femoris. This surface separates the outer from the inner vastus muscle.

When the extensor muscles are relaxed, as in Fig. 55, the groove indicating the Band of Richer becomes apparent, and a tightening round the lower border of the vastus internus is evident. The patella drops from the former position, and the folds of fat protrude on either side of the ligament.

When the knee is flexed, as in Fig. 56, the patella is drawn upwards and outwards; at the same time it is tilted a little backwards by the tension of the tendons and skin stretched over the knee joint. The fatty folds in front of the joint seem to disappear, and the condyles of the femur become very prominent, giving altogether a squarer appearance to the anterior surface modelling of the knee.

THE MUSCLES OF THE LEG

THE ANTERIOR MUSCLES

The anterior group of muscles consists of the tibialis anticus, the long extensor of the toes, the extensor of the big toe, and the peroneus tertius.

The tibialis anticus is the foremost of the anterior group. It arises from the outer tuberosity of the tibia. When the muscle is in action its thick, fleshy upper part obscures about two-thirds of the anterior border of the tibial shaft, rounding and softening the contour of the leg. About the lower third the muscular fibres of the tibialis anticus taper to a long, flat tendon which passes obliquely forwards and inwards to the inner border of the foot.

The long extensor muscle of the toes, lying next to and on the outer side of the tibialis anticus, originates from the upper ends of both the tibia and fibula. This muscle becomes tendinous about the lower third of the leg and, passing in front of the ankle joint, extends to the extremities of the four toes.

The origin of the extensor of the big toe lies deep. The muscle becomes superficial about the ankle joint where it emerges on a long tendon between the two former muscles, and extends to the extremity of the big toe.

The peroneus tertius lies on the outer side of the long extensor of the toes. Its origin lies deep beneath this long extensor muscle. It can be traced where it passes in front of the ankle joint on a slender tendon to the outer border of the foot.

THE OUTER MUSCLES

The outer group of muscles consists of the peroneus longus and the peroneus brevis.

THE OUTER MUSCLES

The peroneus longus arises from the head and outer surface of the fibula. Its fibres end obliquely about the middle of the leg on a very long tendon which passes behind the lower end of the fibula to the foot. The peroneus brevis is partially covered above by the long peroneus muscle. It emerges at the ankle and passes behind the fibula along with the tendon of the peroneus longus, and thence to the foot.

THE POSTERIOR MUSCLES

The posterior group of muscles is composed of three; the gastrocnemius, the soleus and the long flexor of the toes. The soleus and the gastrocnemius extend the foot, acting on the foot only at the ankle joint. Both raise the heel. The gastrocnemius helps to flex the leg upon the thigh.

The gastrocnemius is the only superficial muscle of the leg that originates from above the knee. Arising by two heads from the condyles of the femur, it swells out to form the beautifully shaped calf muscle, its fleshy part somewhat fuller and descending lower on the inner side. About the lower half of the leg the muscular fibres on both sides end on a broad tendon that tapers downwards to the heel. This tendon is known as the tendo Achillis.

The soleus is overlaid by the gastrocnemius excepting for its two lateral borders, the one on the outer side being superficial throughout, the inner one being apparent only on the lower half of the leg. This broad muscle joins with the tendon of the gastrocnemius and descends with it to the heel.

The tendon of the long flexor of the toes is superficial on the lower and inner side of the leg between the soleus muscle and the tibia, and also behind the lower end of the tibia.

SURFACE FORMS OF THE LEGS

The contour of the front of the leg, though directly that of the tibialis anticus, is influenced by the shape and direction of the tibial shaft lying beneath it. A narrow intermuscular marking can be seen between the tibialis anticus and the long extensor muscle of the toes; a deeper one is visible between the peroneus tertius and the lower end of the fibula.

The outer side of the leg presents a flattish curve. The shaft of the fibula is almost entirely covered by muscular or tendinous forms leaving only the head to be indicated by a depression. The lower end of the fibula emerges in front of the peronei muscles. When the model is standing, if the foot is turned outwards and slightly raised on the outer side, the linear indentations between the narrow muscular forms on the outer side of the leg will be seen.

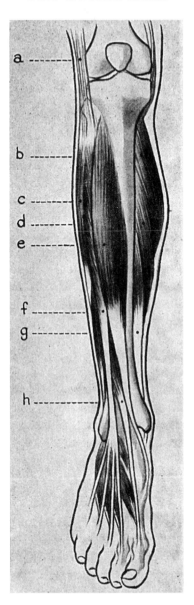

THE MUSCLES OF THE LEG
FIG. 57. From the front

a. Ilio-tibial band
b. Gastrocnemius
c. Peroneus longus
d. Soleus
e. Tibialis anticus
f. Long extensor of the toes

g. Long flexor of the toes
h. Extensor of the big toe
i. Common tendon of the extensors
 of the thigh
k. Tendo Achillis
l. Inner abductor of the foot

From behind there is little evidence of the bones of the leg. The head of the fibula may be indicated above if the leg is a thin one, but usually the massive breadth of the combined gastrocnemius and soleus muscles hides all but the lower ends of the leg

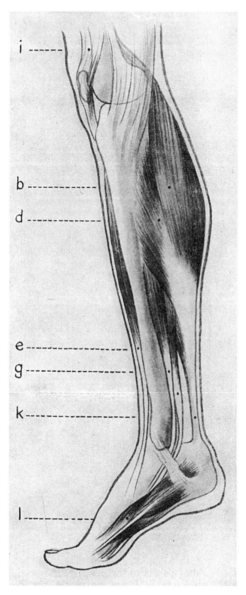

THE MUSCLES OF THE LEG
FIG. 58. From the inner side
See key to Fig. 57

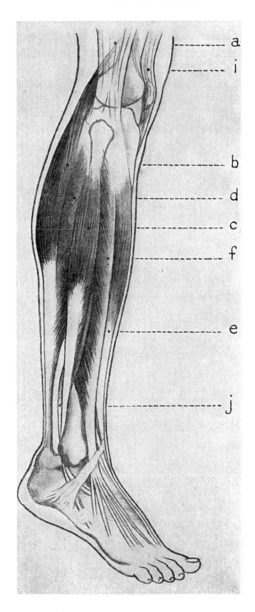

THE MUSCLES OF THE LEG
FIG. 59. From the outer side

a. Ilio-tibial band f. Long extensor of the toes
b. Gastrocnemius g. Long flexor of the toes
c. Peroneus longus i. Common tendon of the extensors of the thigh
d. Soleus j. Peroneus brevis
e. Tibialis anticus k. Tendo Achillis

bones. If the model stands on tiptoe the muscular forms on the back of the leg come visibly into action, the lower muscular borders of the gastrocnemius becoming very prominent as the muscle contracts and hardens.

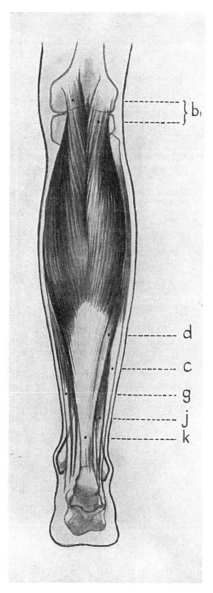

THE MUSCLES OF THE LEG
FIG. 60. From the back
See key to Fig. 59

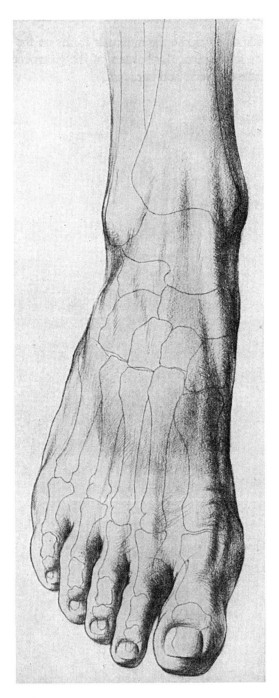

FIG. 61. THE SURFACE FORMS OF THE RIGHT FOOT FROM THE FRONT
showing the position of the skeleton

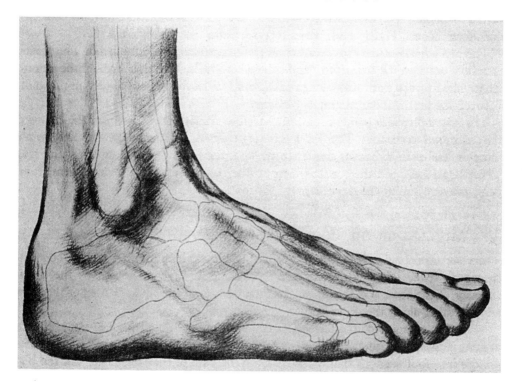

FIG. 62. THE SURFACE FORMS OF THE RIGHT FOOT FROM THE OUTER SIDE
showing the position of the skeleton

THE SKELETON OF THE FOOT

The weight of the body is transmitted through the tibia to the foot. The lower surface
of the tibia rests on the uppermost of the tarsal bones. The tarsal bones, seven in
number, occupy almost half the length of the foot and form the tarsus, the arched
structure of the foot. The tarsus bears the weight of the body. The foot, being set at
right angles to the leg, distributes the weight of the body forwards to the anterior
ends of the metatarsals, and backwards to the heel bone or os calcis.

The largest of the tarsal bones is the os calcis. This bone is expanded behind to
form the prominence of the heel, to which the tendo Achillis is attached. The astra-
galus, the next bone in point of size, rests on the front part of the os calcis. The upper
surface of the astragalus provides the highest part of the instep of the foot, and upon
this bone the broad lower surface of the tibia rests. The scaphoid lies to the front of the
astragalus. This bone projects prominently on the inner border of the foot. The cuboid
occupies the outer side of the foot, and is prominent on this border. Wedged in front

of the scaphoid, and articulating on the outer side with the cuboid, lie three small cuneiform bones. These seven bones together form the tarsus of the foot.

The metatarsals of the foot correspond to the metacarpals of the hand. The metatarsals lie between the cuneiforms and cuboid behind, and the phalanges of the toes in front. The forward part of the longitudinal arch of the foot comes to rest on the joint between the first metatarsal and its phalanx.

The tarsus provides points of insertion for the tendons that pass from the leg over the ankle joint to the foot. The fascia of the leg thickens in front of the joint and forms more or less distinct bands, similar to those at the wrist, called annular ligaments. These ligaments bind the tendons close to the bones, and thus prevent them from being drawn away by the movements of the foot.

THE MUSCLES OF THE FOOT

There are numerous muscles on the sole of the foot which are deep-seated beneath the pads. Three of these muscles are more superficial than the others: the short extensor of the toes, and the two abductors, one along the inner border of the foot and the other along the outer border.

The short extensor of the toes arises from the outer side of the heel bone. Broad at first, it passes obliquely inwards over the upper part of the tarsus. As it does so it divides into four tendons that extend, one to the base of the first phalanx of the big toe, the others, joining with the long extensor muscle, to the second, third and fourth toes. This muscle of the foot crosses the tarsus beneath the anterior group of the leg muscles. The fleshy part of this extensor muscle is distinguishable in two places, in front of and below the fibula between the tendon of the peroneus tertius and the peronei muscles on the outer side of the leg, and again on the upper part of the tarsus between the long extensor of the toes and the extensor of the big toe.

The abductor on the inner side of the foot is thick and broad. It originates from the heel and extends to the base of the first phalanx of the big toe. The outer abductor also originates from the heel bone and is inserted into the base of the fifth metatarsal. The inner muscle is both an abductor and a flexor of the big toe; the outer muscle acts in a similar way on the little toe. These muscles, by the extension of their fleshy parts, form part of the contours along the inner and outer borders of the foot.

SURFACE FORMS OF THE FOOT

The anterior tendons from the leg muscles are noticeable in front where they are drawn together into a cluster by the ligament which passes across the joint. The tendons spread out from here over the tarsus in a fan-shaped manner to the borders and extremities of the foot. The bony structure of the tarsus presents almost a right

angle as it joins with the leg bones in front; this angular formation, however, is softened by the tendons which, passing over it, give a smoother, curved contour in front of the ankle joint.

When the peronei muscles are in action their tendons can be traced behind and beneath the lower end of the fibula. Passing through a ligament on the outer side of the os calcis, they emerge again along the side of the cuboid.

On the inner side of the foot lie the tendons of the two long flexors of the toes and the tibialis posticus. The tibialis posticus is for the most part deep, but its tendon, passing beneath the lower end of the tibia, can be seen, when the foot is everted, to bridge the concavity between this bone and the scaphoid, into whose tuberosity it is inserted.

INDEX

INDEX

INDEX

INDEX

A CATALOG OF SELECTED
DOVER BOOKS
IN ALL FIELDS OF INTEREST

A CATALOG OF SELECTED DOVER
BOOKS IN ALL FIELDS OF INTEREST

CONCERNING THE SPIRITUAL IN ART, Wassily Kandinsky. Pioneering work by father of abstract art. Thoughts on color theory, nature of art. Analysis of earlier masters. 12 illustrations. 80pp. of text. 5⅜ x 8½. 23411-8

ANIMALS: 1,419 Copyright-Free Illustrations of Mammals, Birds, Fish, Insects, etc., Jim Harter (ed.). Clear wood engravings present, in extremely lifelike poses, over 1,000 species of animals. One of the most extensive pictorial sourcebooks of its kind. Captions. Index. 284pp. 9 x 12. 23766-4

CELTIC ART: The Methods of Construction, George Bain. Simple geometric techniques for making Celtic interlacements, spirals, Kells-type initials, animals, humans, etc. Over 500 illustrations. 160pp. 9 x 12. (Available in U.S. only.) 22923-8

AN ATLAS OF ANATOMY FOR ARTISTS, Fritz Schider. Most thorough reference work on art anatomy in the world. Hundreds of illustrations, including selections from works by Vesalius, Leonardo, Goya, Ingres, Michelangelo, others. 593 illustrations. 192pp. 7⅛ x 10¼. 20241-0

CELTIC HAND STROKE-BY-STROKE (Irish Half-Uncial from "The Book of Kells"): An Arthur Baker Calligraphy Manual, Arthur Baker. Complete guide to creating each letter of the alphabet in distinctive Celtic manner. Covers hand position, strokes, pens, inks, paper, more. Illustrated. 48pp. 8¼ x 11. 24336-2

EASY ORIGAMI, John Montroll. Charming collection of 32 projects (hat, cup, pelican, piano, swan, many more) specially designed for the novice origami hobbyist. Clearly illustrated easy-to-follow instructions insure that even beginning papercrafters will achieve successful results. 48pp. 8¼ x 11. 27298-2

THE COMPLETE BOOK OF BIRDHOUSE CONSTRUCTION FOR WOODWORKERS, Scott D. Campbell. Detailed instructions, illustrations, tables. Also data on bird habitat and instinct patterns. Bibliography. 3 tables. 63 illustrations in 15 figures. 48pp. 5¼ x 8½. 24407-5

BLOOMINGDALE'S ILLUSTRATED 1886 CATALOG: Fashions, Dry Goods and Housewares, Bloomingdale Brothers. Famed merchants' extremely rare catalog depicting about 1,700 products: clothing, housewares, firearms, dry goods, jewelry, more. Invaluable for dating, identifying vintage items. Also, copyright-free graphics for artists, designers. Co-published with Henry Ford Museum & Greenfield Village. 160pp. 8¼ x 11. 25780-0

HISTORIC COSTUME IN PICTURES, Braun & Schneider. Over 1,450 costumed figures in clearly detailed engravings–from dawn of civilization to end of 19th century. Captions. Many folk costumes. 256pp. 8⅜ x 11¾. 23150-X

THE STORY OF THE TITANIC AS TOLD BY ITS SURVIVORS, Jack Winocour (ed.). What it was really like. Panic, despair, shocking inefficiency, and a little heroism. More thrilling than any fictional account. 26 illustrations. 320pp. 5⅜ x 8½.
20610-6

FAIRY AND FOLK TALES OF THE IRISH PEASANTRY, William Butler Yeats (ed.). Treasury of 64 tales from the twilight world of Celtic myth and legend: "The Soul Cages," "The Kildare Pooka," "King O'Toole and his Goose," many more. Introduction and Notes by W. B. Yeats. 352pp. 5⅜ x 8½.
26941-8

BUDDHIST MAHAYANA TEXTS, E. B. Cowell and others (eds.). Superb, accurate translations of basic documents in Mahayana Buddhism, highly important in history of religions. The Buddha-karita of Asvaghosha, Larger Sukhavativyuha, more. 448pp. 5⅜ x 8½.
25552-2

ONE TWO THREE . . . INFINITY: Facts and Speculations of Science, George Gamow. Great physicist's fascinating, readable overview of contemporary science: number theory, relativity, fourth dimension, entropy, genes, atomic structure, much more. 128 illustrations. Index. 352pp. 5⅜ x 8½.
25664-2

EXPERIMENTATION AND MEASUREMENT, W. J. Youden. Introductory manual explains laws of measurement in simple terms and offers tips for achieving accuracy and minimizing errors. Mathematics of measurement, use of instruments, experimenting with machines. 1994 edition. Foreword. Preface. Introduction. Epilogue. Selected Readings. Glossary. Index. Tables and figures. 128pp. 5⅜ x 8½. 40451-X

DALÍ ON MODERN ART: The Cuckolds of Antiquated Modern Art, Salvador Dalí. Influential painter skewers modern art and its practitioners. Outrageous evaluations of Picasso, Cézanne, Turner, more. 15 renderings of paintings discussed. 44 calligraphic decorations by Dalí. 96pp. 5⅜ x 8½. (Available in U.S. only.)
29220-7

ANTIQUE PLAYING CARDS: A Pictorial History, Henry René D'Allemagne. Over 900 elaborate, decorative images from rare playing cards (14th–20th centuries): Bacchus, death, dancing dogs, hunting scenes, royal coats of arms, players cheating, much more. 96pp. 9¼ x 12¼.
29265-7

MAKING FURNITURE MASTERPIECES: 30 Projects with Measured Drawings, Franklin H. Gottshall. Step-by-step instructions, illustrations for constructing handsome, useful pieces, among them a Sheraton desk, Chippendale chair, Spanish desk, Queen Anne table and a William and Mary dressing mirror. 224pp. 8⅛ x 11¼.
29338-6

THE FOSSIL BOOK: A Record of Prehistoric Life, Patricia V. Rich et al. Profusely illustrated definitive guide covers everything from single-celled organisms and dinosaurs to birds and mammals and the interplay between climate and man. Over 1,500 illustrations. 760pp. 7½ x 10⅛.
29371-8

Paperbound unless otherwise indicated. Available at your book dealer, online at **www.doverpublications.com**, or by writing to Dept. GI, Dover Publications, Inc., 31 East 2nd Street, Mineola, NY 11501. For current price information or for free catalogues (please indicate field of interest), write to Dover Publications or log on to **www.doverpublications.com** and see every Dover book in print. Dover publishes more than 500 books each year on science, elementary and advanced mathematics, biology, music, art, literary history, social sciences, and other areas.